Secrets to Painting Realistic Faces in Watercolor

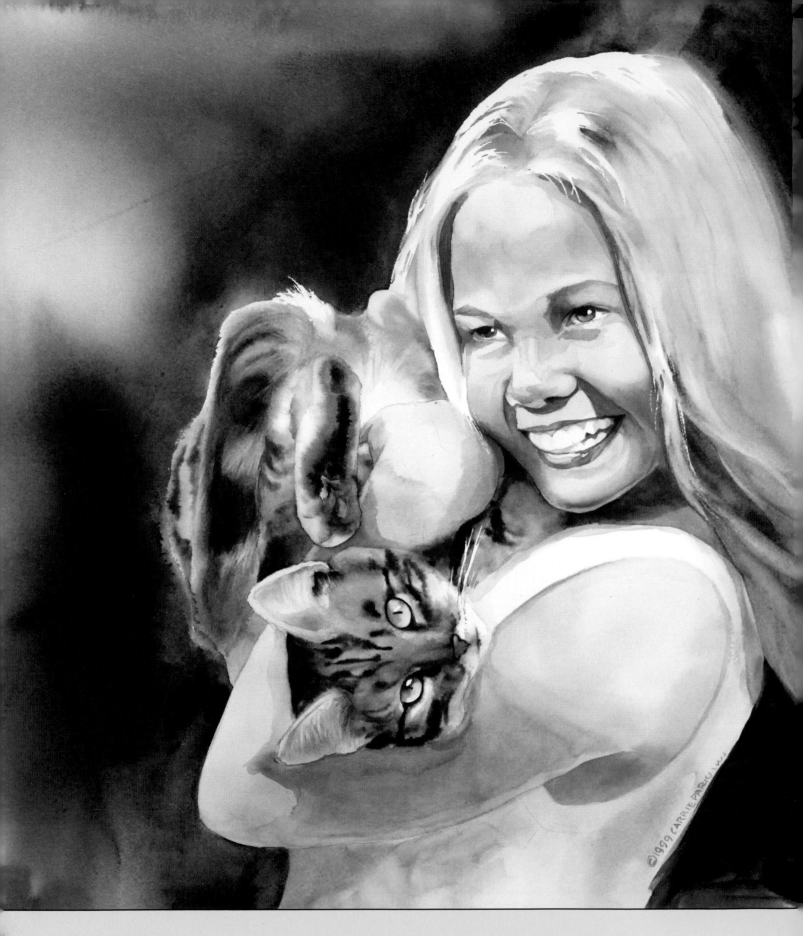

POINT OF VIEW
30" × 22" (76cm × 56cm)
Transparent watercolor on Arches 140-lb. (300gsm) cold-pressed paper

secrets to
PAINTING
REALISTIC FACES
in WATERCOLOR

CARRIE STUART PARKS
& RICK PARKS

NORTH LIGHT BOOKS
CINCINNATI, OHIO
www.artistsnetwork.com

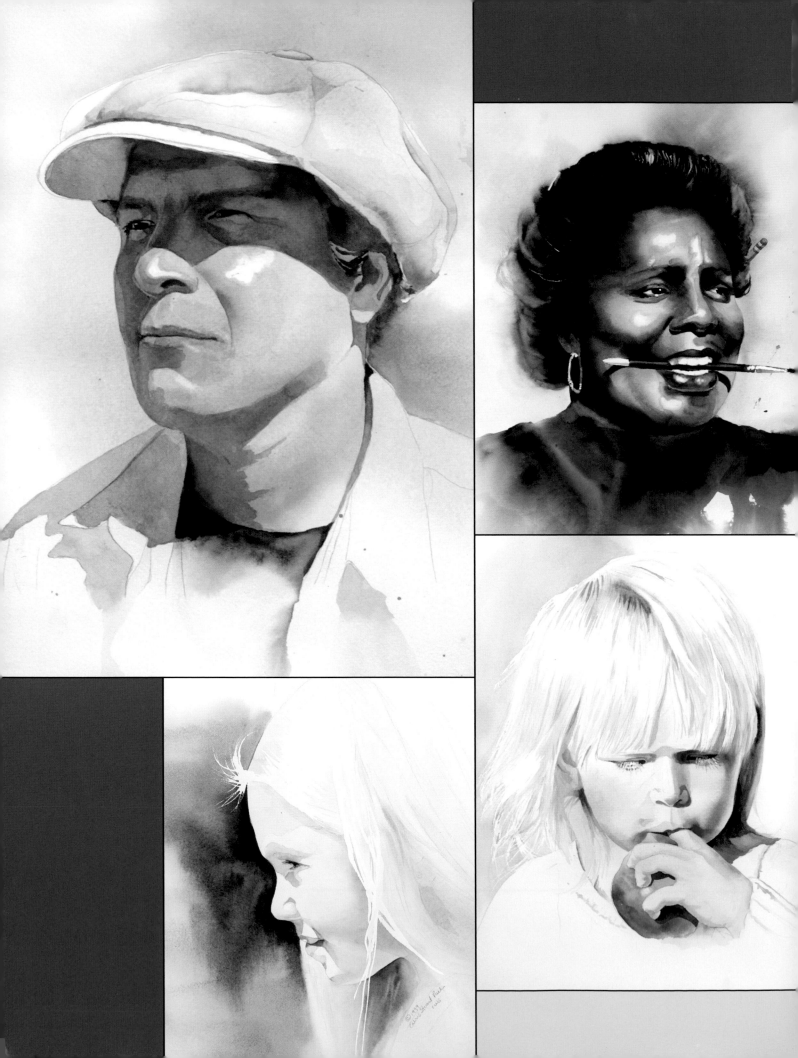

TABLE OF CONTENTS

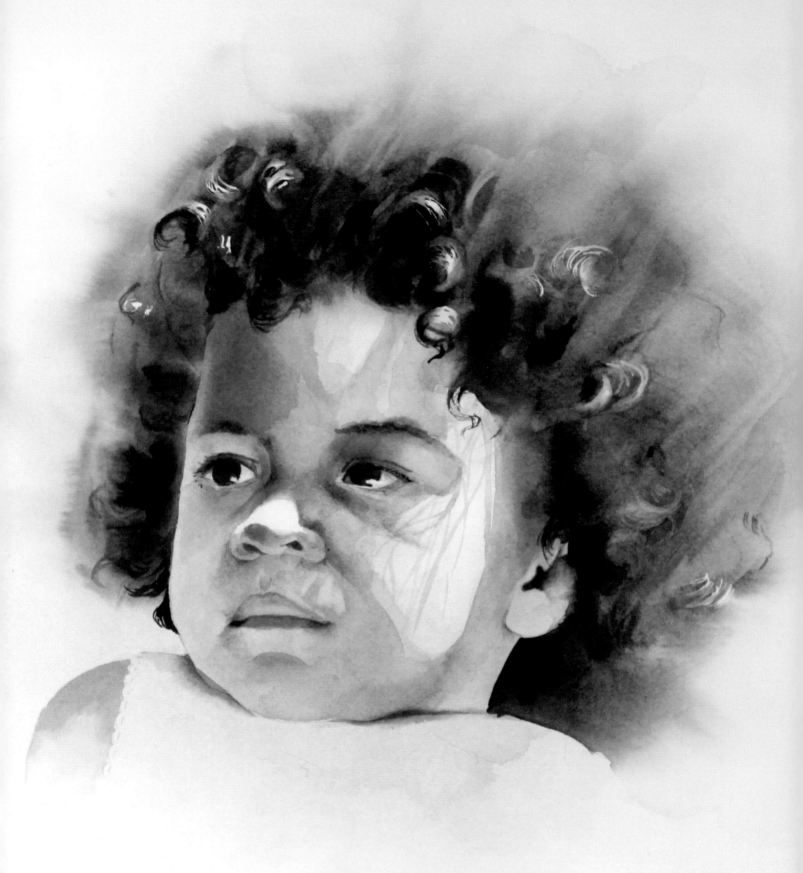

Introduction

I'm so excited that I'm running around my studio doing my finger-popping happy dance. Why? Because I've written a watercolor portrait book for North Light! I have authored three drawing books to date (and you really need these books, by the way), but watercolor is my true love (sorry, Rick). I've painted in watercolor since 1968, a remarkable feat as I wasn't born until . . . um . . . a long time after that.

I love watercolor, and I know you will love it, too. It's a wonderful medium, full of life, expanding and challenging you with its ever-changing moods. I want you to have every secret, every tool, every technique, every shortcut and every success in your painting. I want you to feel that you've found your true artistic style and expression with this medium.

Not only have I painted in watercolor forever (or at least since the last of the dinosaurs became extinct), but I've also taught classes and attended many workshops. I know about the difficulties in learning something new and how to smooth the learning process.

What Is "Real"?

For those of you who are picky about language, in the context of this book, achieving a "real" likeness means you can identify the person I've painted; it doesn't mean painstaking photorealism. So, you could identify the person, assuming you knew whom I painted. You get my drift. Now that we've cleared that up, before you reach for a brush or pencil, I'd like to share some profound thoughts about watercolors with you.

CHIARA
22" × 22" (56cm × 56cm)
Transparent watercolor on Arches 140-lb. (300gsm) cold-pressed paper

Profound Thoughts

In this book, I'm sharing my particular style and thoughts on painting portraits in watercolor. It isn't going to be everybody's cup of tea. For example, I like watercolors to look like watercolors—juicy, wet-on-wet paintings that involve the imagination of the viewer. I get excited about a painting that looks like it was just snatched back from the edge of disaster with a masterful stroke. As such, I'm not trying to nail down the exact skin shade or the tightest representation of every eyelash. I like my paintings to be loose. This may push you out of your comfort zone when all you really want to do is paint a portrait of your precious granddaughter and not have her mother stop speaking to you for six months. Don't stress. It's always easier to get tight in your painting.

Don't Sweat the Small Stuff

I had a woman in one of my watercolor classes several years ago. Let's call her Ida. Dear Ida struggled with the medium of watercolor for several weeks. She came from an oil painting background where she was used to pounding the painting with mighty blobs of color, hoping to subdue and control it with sheer force of will.

This particular Saturday in our watercolor class, she wet her paper, dipped her brush in a blend of Indigo and Prussian Green with a hint of coral, swiped across her damp paper and stopped. The pigment bled, forming a stormy sky above a restless sea, with the sun about to break through the cloud layer. She gasped, causing her hand to jerk slightly, and a tiny drop of color landed in the center of the clearing horizon. Her intake of air caused me to wander over and check her progress. The painting was breathtaking. You could smell the salt air and feel the puffs of wind. A quick flick with a tiny brush had turned her accidental drip into a distant seagull.

She left the room at the end of class that day clutching the painting in both hands, like a prized offering to an ancient king.

After getting home, she decided that the painting came too easily and she needed to work more on it. She added a childlike, outlined Cadmium Red boat in the center of the picture. The following week she returned to class. In tears.

Dear Ida learned a priceless lesson the hard way: quit while you're ahead.

Throughout this book, I will stress that getting a true likeness begins with a good photograph.

Although you don't have to complete a detailed drawing of your subject, you'll want to work out the details on drawing paper, then transfer the drawing to watercolor paper.

Tip

Don't give up. There are only two kinds of watercolorists: those who have been frustrated and those who will be frustrated.

From Drawing to Painting

I want to share with you two mighty secrets to successful watercolors:

1. The underlying drawing must be sound.
2. You'll need practice. Lots of practice.

Pencil Before Paintbrush

Let's look at the underlying drawing first. You'll need to begin with a clear, large, easy-to-see photograph. Practice with photographs of people you don't know. Don't start with the "but-but-but I wanna paint my mom!" We're getting there. You need to be free to practice and make a royal botch-up of your practice work. You don't want to mess up your mom's painting. You don't want, or need, the tension that comes from trying to make it perfect. From Chapter 3 onward, we'll examine more closely the how-tos of drawing for painting.

One final note before you continue in this book: It's not just art, it's a vocabulary lesson. I use certain words to describe some watercolor concepts. I don't think you'll find these terms taught in formal art classes. They're descriptive. They're fun. Like, for example, "noodling." A lot of new artists noodle hair. They paint each strand, ending up with a portrait that looks like someone dumped a bowl of spaghetti on the person's head. "Noodling" is overworking your painting. Don't noodle.

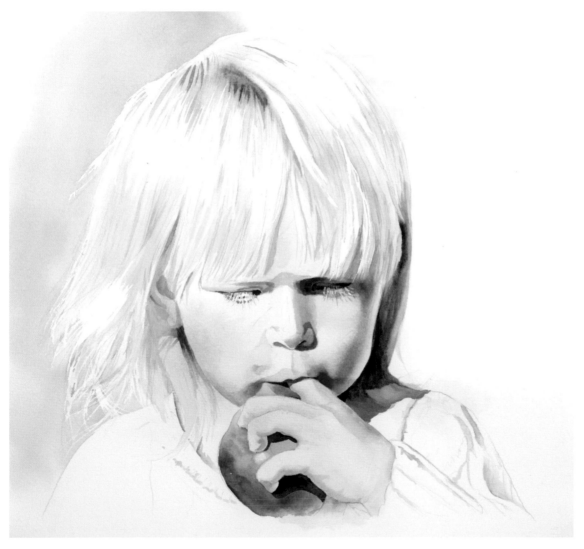

PAYTON (DETAIL)
24" × 18" (61cm × 46cm)
Transparent watercolor on Arches 140-lb. (300gsm) cold-pressed paper

Chapter 1

Materials and Supplies

If you've read any of my previous books (and I consider you brilliant for doing so), you'll know that art is all about the "stuff." Really cool stuff. Stuff is as necessary to art as correct shoes are to marathon runners. So I've been told, anyway.

I have a lot of art supplies. An entire studio full of brushes, paints, paper, pencils, drawing tables, palettes. You name it, I've probably got it. No, I'm not an art-hoarder, more like a collector. That's what I keep telling my husband.

Artists, Like Astronauts, Need the Right Stuff

Let me share my art-supplies philosophy. Over the years, I've taken a number of watercolor classes from big-poobah artists like Nita Engle, Charles Reid, Barbara Nechis and numerous others. I buy their recommended palettes, paints, brushes and paper. I attend their workshops and watch their every move, paint what they paint, stick out my tongue and stand on one foot if that's what they do. I mimic the artists I admire, and it helps me to learn their secrets.

I'm telling you this for a reason. At these workshops are students who substitute the paper, paint, brushes and so on because they want to save money. Guess what? They don't learn all that instructor is teaching because they're not using the correct tools.

You may need to go shopping. There, I've said it. You can highlight that sentence and show it to your significant other if they don't fully understand.

CAROLYN CRAWFORD
22" × 22" (56cm × 56cm)
Transparent watercolor on Arches 140-lb. (300gsm) cold-pressed paper

Art Supplies Necessary for Life

Brushes

You'll need—and I do mean need—a couple of good brushes. My favorite brush is a Winsor & Newton Series 995 1-inch (25mm) wash brush. It's a flat, which I prefer to a round for most of my painting. Flat brushes have their challenges, the biggest being that they lift underlying pigment. That's not a problem unless you want to build color. For layering, I like a soft round brush like a pure Kolinsky. I also use brushes with a blend of hairs, not just sables. My third brush is a larger flat wash. I like the Robert Simmons Skyflow 2-inch (51mm). For most of my layered paintings, I use some of my favorite Connoisseur brushes.

While you're shopping, pick up a spiffy brush holder. Mark your brushes with nail polish or tape so they don't get mixed up with someone else's at a class.

Paper and Paint

Except where noted, I use Arches 140-lb. (300gsm) cold-pressed paper. How's that for simple? I've found Fabriano Artistico cold-pressed to also be a very nice paper. Buy a bunch. First of all, you get a price break. More important, you'll be much freer in your painting when you have spare paper, not so likely to be chewing your nails and thinking, "Omigosh, this is my last piece of paper. What if I make a mess of it?" Arches watercolor paper allows you to paint on either side, but I much prefer the smoother side. Hold the paper to the light. If you can read "Arches" as a watermark, you're painting on the smooth side.

My first choice for watercolor paints is the line of professional pigments from M. Graham. Based in the Portland, Oregon, area, M. Graham paints are rich in pigment and contain an old-fashioned binding medium of natural blackberry honey and pure gum arabic. That makes the color easily diluted and very intense, and prevents it from forming a cement block on your palette. Their website has an easy-to-use resource of stores in your area that carry this paint. Trust me, you'll love it. I would avoid, with a deep-seated hostility, the student-grade watercolors. It's better to have a few paints of professional caliber than a lot of paints suitable for . . . well, something other than watercolor.

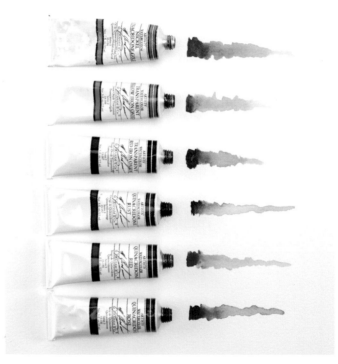

M. Graham watercolors on Arches 140-lb. (300gsm) cold-pressed paper. Colors from top to bottom: Nickel Quinacridone Gold, Transparent Yellow Iron Oxide, Transparent Red Iron Oxide, Quinacridone Rust, Quinacridone Red and Quinacridone Rose.

My Basic Color Choices

Nickel Quinacridone Gold
Transparent Yellow Iron Oxide
Transparent Red Iron Oxide
Quinacridone Rust
Quinacridone Red
Quinacridone Rose
Cadmium Red
Maroon Perylene

My favorite brushes, from left to right: Robert Simmons Skyflow 2-inch (51mm), Connoisseur 1-inch (25mm), Winsor & Newton Series 995 1-inch (25mm) and a couple of blended rounds, also made by Connoisseur.

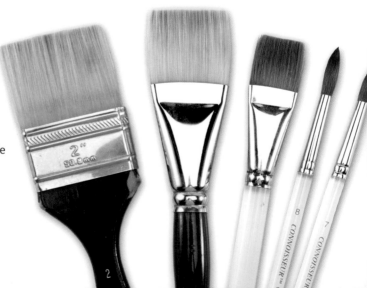

I soak my paper in a tub of cool water for less than ten minutes, then stretch it on a board using paper tape, wood glue and staples. It's a pain in the padukies. I don't like to stretch paper unless it's absolutely necessary.

Watercolor Boards, Stretching and Other Forms of Exercise

I mount my paper on some form of board. I've used plywood as a support, but only after sealing it first with polyurethane to keep the wood acid from staining the paper. Right now I'm hooked on Gator board, a strong, rigid, but lightweight product found at many supply stores. I use beige-colored drafting tape or clips to hold down the corners. Lots of my students use blue painter's tape and tape the paper down all the way around the art.

Don't do that.

First of all, you're placing a bright-blue color in front of you. That will strongly influence your color choices when painting. Also, the tape isn't over stretched paper, so your art will buckle, and water will gather on the tape and roll back into your beautiful painting.

Let's talk about stretching, not just to start your exercise program. Many artists will stretch their paper. What does this mean? Watercolor paper will buckle when wet. Stretching means that you soak the paper in water for a period of time to loosen the fibers. Then you place the paper on a backing board, tug the paper tight and fasten it to the board with either staples or a combination of paper tape and staples. When you paint, the paper will remain absolutely flat. I will stretch my paper if (a) I'm painting water, like a landscape with a lake, or (b) I'm painting larger than a full sheet, over 22" × 30" (56cm × 76cm). Otherwise, don't stretch your paper. Why? I knew you'd ask that. Because it takes hours, or overnight, to dry enough so you can paint on it. So you wait. It's now time. You pick up your brush. You're facing that blank sheet of watercolor paper with twenty-four hours of work already invested in it. You hesitate. One thoughtless move, one bad dip of the brush into the wrong color, and you've wasted that now-precious piece of paper. You break out in a cold sweat. You can't make a mistake. See? You need to be free of all that tension. Life is just too short. It's only a piece of paper.

Palettes

I think I must own about every palette there is. Most are made of plastic and have wells where you squeeze your paints. I've gone so far as to laboriously and neatly label each color with a permanent marker. I even own a remarkable palette that survived flying off a car roof and landing on hard pavement.

There are a couple of problems with watercolor palettes. First, it's hard to clean the colors without making a mess. If you run the palette under water, the red runs into the yellow, then green, then, ugh. Second, I change my mind on color. Maybe this year I'm deeply in love with Olive Green. Next year I might lust after Cadmium Orange. There are only so many wells for the paint. Plus, I've written all over it. So much for the plastic palettes. Now I use a butcher tray and put just the colors I'm working with on the tray.

Preserving Whites

There are times when I want to preserve white areas without painting around them or cramping my style (sloppy, soggy, lots of paint flying—believe me, it takes years to become that reckless), so I use a masking fluid. I like Pebeo Drawing Gum best. It doesn't rip up the surface of the paper when you remove it. In this respect, it's unique. There are three cautions: (1) don't leave it on the paper for more than a month (you can always reapply it), (2) don't place it in the sun to dry—it becomes "one with the paper," and (3) apply it on dry paper only.

Masking fluid is your friend, as are a selection of cheap brushes, a Fritch scrubber and a ruling pen.

I use only cheap brushes to apply masking fluid as I've found my best efforts at cleaning up still result in gooey leftover residue. You can wash the brush first in mild soapy water before you paint to have less leftover glop. To make fine, hairlike white lines, I use a ruling pen. I'll also use a Fritch scrubber to soften edges. Purchase a rubber cement pick-up to help remove dried masking and you're good to go.

Palette Layout

I mentioned earlier that I don't really use a palette with colors already laid out in neat wells. I squeeze a blob (thumbnail size) of color onto a butcher tray, smoosh part of it around and introduce it to a second or third color. I'll get into the finer points of smooshing later, but the point I want to make here is that I don't usually want a gallon or two of the same color unless I'm painting my bathroom. I want each stroke to have a slightly different mix of color so there's more interest in the painting.

Odds and Ends

Some other items you'll want to add to your collection are a sponge, spray bottle, hair dryer and water containers (use cool water in two containers: one for dirty brushes, one for clean). I like a roll of white paper towels to remove excess water from my brush and to check and see if I have washed out all the pigment from my brush. If you use a roll of toilet paper, you should invest in a different roll for each painting. That's a lot of TP. A used roll (as in, used in watercolor paintings) makes it hard to check your brush for leftover pigments.

Ready to Paint

I've dribbled across my paintings enough—not to mention washed my brushes out in my morning coffee—that now I place my palette, brushes and water on one side, with my beverage of choice on the other. I paint standing up, which gives me the freedom of movement in my arms as well as the ability to move around. Standing up will keep your paintings much looser. You can sit for details. I paint on a counter in my studio that is the correct height for me.

I use a butcher tray and lay out the colors so when I drag my brush through them, I pick up a slightly different color combination each time.

Additional watercolor items to round out your collection: an assortment of spray bottles, white paper towels, water container and sponges (including a Mr. Clean Magic Eraser), all together in a fancy-schmancy basket.

Summary of Painting Supplies

Palette
Water containers (2)
Brushes
Professional-quality fresh watercolor paint
Board or other support
Arches 140-lb. (300gsm) cold-pressed watercolor paper
Tape or clips to secure the paper
Reference photos
Paper towels

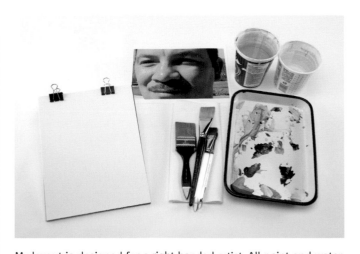

My layout is designed for a right-handed artist. All paint and water, along with a folded paper towel, are on the right side.

Basic Drawing Supplies

Pencils

Unlike in my drawing books (and, by the way, did you pick up copies of them yet?), you won't need a large selection of pencils. I strongly recommend you do not work out your underlying sketch directly on the watercolor paper unless you're doing life painting. Strongly. As in—don't do it. I'll cover how to transfer your drawings to watercolor paper in Chapter 3, but for now just understand that you need to protect the surface of your paper, and constant erasing makes it a mess. My drawings directly on the paper are done with an HB pencil, and my transferring is done with a 6B pencil.

Erasers

It's hard to wax eloquent about erasers in an art book. They erase. What else is there to say? Ah, but when it comes to watercolor, erasers play a big part. Our primary eraser is a kneaded rubber eraser, with a backup white plastic eraser. Next we'll address the age-old question: What do you do about the pencil lines that show when you're done with your painting? Should you erase them or leave them? Your underlying pencil sketch is part of the art. I'd leave the lines unless they no longer define or add to the art. If you've become too vigorous in applying pencil strokes and they are too dark, you might consider dabbing the extra graphite out before painting. That graphite residue will lift with water and add a slightly gray layer to your art. Not nice.

Drawing Paper

My detailed drawings are done on Strathmore Series 400 smooth bristol. I like the surface for my drawing style and it erases better than the Series 300. Sketching is done on any decent sketch pad although I do like my paper to be quite white. Transferring the drawing is covered in Chapter 3, but you'll want to pick up some tracing paper.

I love smooth bristol paper for drawing, as well as sketch paper and a good grade of tracing paper for transferring the drawing to my watercolor paper.

The kneaded eraser is more for dabbing the excess graphite on your paper. Unless drawing from life, you shouldn't be erasing on your watercolor paper.

You can do most of your work in watercolor with an HB and a 6B pencil. Draw *lightly*.

Rulers and Other Toys

I use a variety of mechanical tools to assist me in drawing although not necessarily with the painting. A C-Thru ruler has a grid that I find useful for centering. Circle templates allow you to make perfectly round irises. An erasing shield helps with tiny corrections. A proportional divider, although expensive, is great for scaling a photograph (more on this later).

Industrial-Strength Investments

I often use an opaque projector to transfer my sketches and drawings onto my watercolor paper. The projector will hold only a limited size original, and there's a possibility of distortion, but it does work well for certain images. A light table also makes a handy tool although you can use the "poor man's light table"—a window on a sunny day.

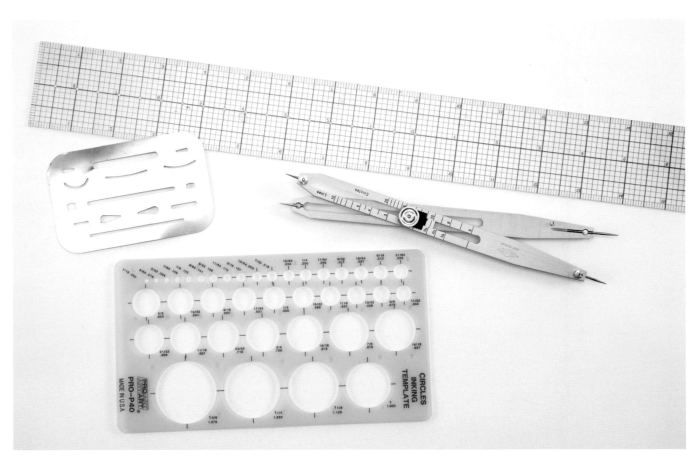

Mechanical tools help your drawings, and the foundation of a successful watercolor painting is a good drawing.

Reference Photos

It always happens. I tell my class to bring a photograph or two of someone they want to draw and paint. At least one person will bring a studio photograph of a dearly loved relative—usually deceased—and spend quality class time crying while attempting to capture that missing something in their painting. When they ask, "What's wrong with my art? My darling niece has such an impish sparkle about her. I just can't seem to capture it," I'm at a loss. The photo doesn't have an "impish sparkle." The painting looks like the photo. They're painting through the eyes of love.

Studio photographs rarely have the kind of interesting lighting that makes for a good painting. They are also copyright-owned by the photographer. You'll want a photograph that's clear, interesting, BIG and one you'll want to paint several times. Don't overlook antique photos, which are fun to paint.

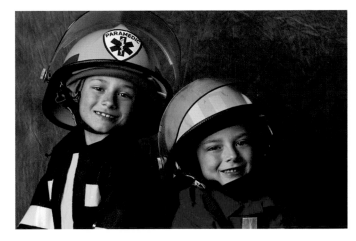

Borrowing from the pros
I usually take my own reference photographs. With permission, I will also use the work of professional photographers. I've been blessed to work with some wonderful photographers for this book. This photo, entitled *The Boys*, is a studio shot by Joe Lofy.

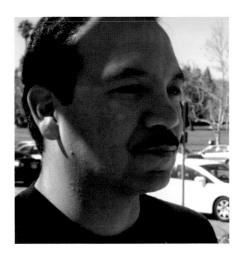

Nice guy, lousy photo
I wanted to paint my friend Rick Perez, but this is a bad choice of photos. The top of his head is missing, and there are strange shadows on his face from a nearby sign. Although Rick has a great sense of humor, lopping off his head might stretch that.

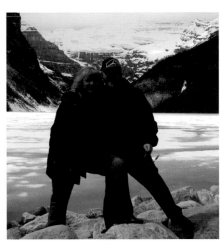

Great fun, bad photo
Aren't we having a great time at Lake Louise in Alberta, Canada! Nice for Facebook, lousy for painting. No detail, small faces, bad lighting.

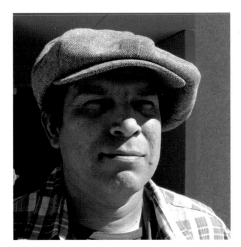

Good choice of subject
Dan made a good subject with the interesting lighting across his face.

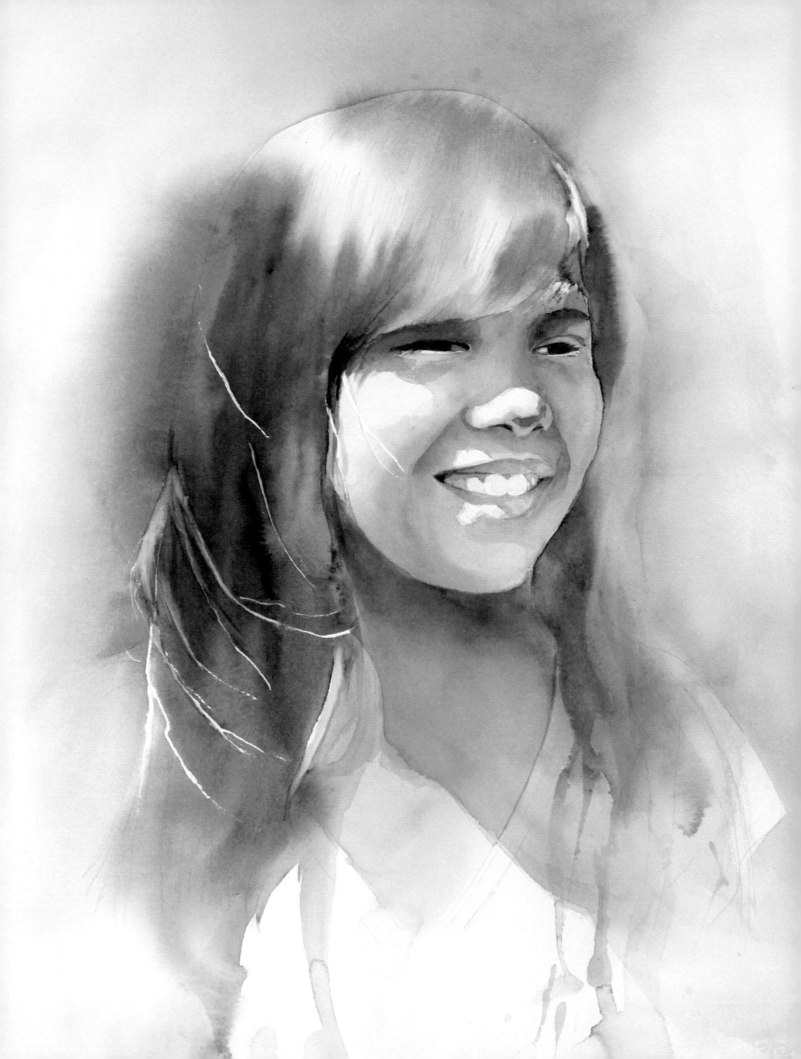

Chapter 2

Watercolor Basics

If you're new to working in watercolors, this chapter contains the basic concepts you'll want to know to create amazing watercolor portraits. Be kind to yourself—watercolors take practice, but they also do a great deal of work quite on their own. Don't think of it so much as controlling the medium as letting the medium do its thing and taking credit for the results. On the following pages, I'll tell you what technique creates a particular look and where you might want to use it on your portraits. I'll also demonstrate some possible problems and how you might avoid them. When you get a watercolor "oops," learn to say, "I meant to do that." So take a deep breath, grab a brush and let's begin.

Sunny Smiles
22" × 22" (56cm × 56cm)
Transparent watercolor on Arches 140-lb. (300gsm) cold-pressed paper

How to Handle Watercolors

Making a Watercolor Wash

Pick up your brush, get it wet, dip it in fresh pigment, smoosh it around on your palette to mix the water a bit with the color, and make a stroke on your paper. Voilà! You've made a wash. A watercolor wash is simply where you apply color to dry paper. It's sort of like painting a wall. Why I'm even mentioning it is that many folks like to paint on their paper as if painting the side of a barn. If one stroke is good, then 473 strokes must be better. First important lesson: Your first brushstroke is usually your best. Don't go back over it unless you absolutely need to.

A graded wash is not one where a teacher might give you a C+. It means the color becomes less intense by applying more and more water into the pigment as you proceed down the paper. I might use some sort of wash for the background or clothing.

Less is more. Learn to not go over your paper with repeated brushstrokes.

Blossoms

Nope, I'm not talking about flowers. A blossom or crawl-back (different artists call it other names) occurs when water snakes into a drier, often pigmented area and forces the paint outward, forming a random, wiggly edge. Blossoms can be fun, but not when they occur on, say, the nose of your portrait subject and resemble some rare skin disease. They can be interesting if they occur in the hair or clothing, possibly even on the edge of a shadow.

Blossoms or crawl-backs, if occurring in the right place, can add interest to a portrait.

Avoiding Blossoms

- *Before putting your color-loaded brush to your paper, touch the back of the brush (close to the ferrule) onto a dry paper towel to discharge excess water.*

- *Dump off excess water from your paper before you paint so puddles don't form.*

- *If using a small brush, watch that water drops aren't hovering on the ferrule waiting to sneak down when you least expect it.*

- *Stop painting when your paper has a matte finish and has lost the shine.*

- *Gently spray-wet your paper again if you see a blossom forming.*

Paint Goes Where Water Flows

Fact: Watercolor paint spreads to everywhere that's wet. It stops when it hits dry paper, unless you're painting on paper that's tilted at an angle. For example, when you're painting along the edge of the nose, perhaps adding a wonderful shadow, you're thinking nose. But that wet paint will continue to spread across the face until it reaches a dry area, then stop. If you've wet only the area you're concentrating on and forget that the paint will wander without your paying attention, you may end up with a bad stroke or line where you don't want it.

Painting Wet-on-Wet

I like putting down color wet-on-wet. That means I wet the paper, and I do mean sloppy, car-wash, over-the-top, soggy wet. I tip my painting board and let excess water run off, then paint on the damp surface with the pigments. This is how I lay on the initial color that will appear underneath the whole of the painting. This keeps my art from looking like a paint-by-number or a floating head glued onto a white piece of paper. The selection of color will be the lightest tone of the skin and a hint of another color or two, such as turquoise or blue around the hair. Watch your color choices here. I'm not crazy about green on the skin, for instance; somehow it just doesn't look healthy. Blue on the skin area can suggest a five o'clock shadow, which isn't the best choice for painting children.

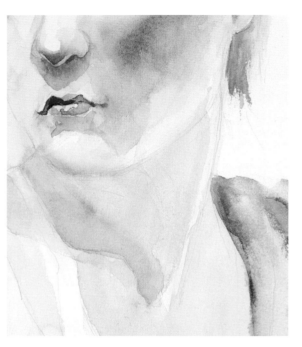

Watercolor pigment spreads across the wet areas of your art. Remember to wet well beyond where you plan on painting to prevent unwanted edges. I was so busy working around the lips here that I ignored the spreading color, which ended up suggesting a shadow in the wrong area to the right of the chin.

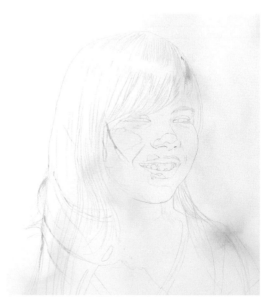

I use the wet-on-wet technique for my underpainting. Notice how subtle the color is.

Wet-on-Wet Pointers

- Depending on your climate, you don't have time for timidity when your paper is wet. If you live in, say, Arizona and it's 110 degrees in the shade, you've got to work fast.

- Don't decide on the color after you've wet your paper. Be ready with the diluted pigment in advance.

- Use a big brush.

- Don't have a puddle of a single color ready to go. Slightly mix two or more colors, making sure you scoop through the mix from a different direction each time you load your brush so each brushstroke has some variety.

- Keep the colors light. You can always rewet and get darker.

- Remember, it's only a piece of paper.

Glazing

Glazing, or layering, is painting a thin stroke of pigment over another dried stroke to build up color. Transparent watercolor works by allowing light to pass through the color, hit the white paper and reflect back. That's why your paintings will look different when the light changes. Each layer should be a slightly different color from the previous to make for an interesting painting. You might start out with a golden underpainting, glaze a layer of rusty orange, then one of red, then gold again. The secrets are keeping the paint quite pale with each layer and letting each layer dry fully before applying the next.

The Dirt on Mud

For some reason, creating mud (usually an accidental mixture of too many colors or of certain complements) is considered uniformly bad. It isn't always a bad thing. A muddied area of your art can make the colorful areas brighter. However, I think it's somewhat unsettling to make someone's portrait muddy unless you're making an artistic statement. I'll sometimes use mud to have you look elsewhere. But too much mud can make the viewer look too far elsewhere—like the painting next to yours.

This is some of the earliest layering on a painting.

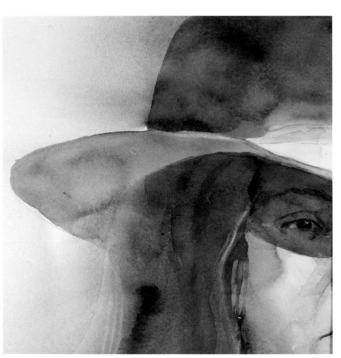

Mud is not a dirty word (pardon the pun). You might use it to guide the viewer's eye elsewhere.

Tip

Here are two glazing secrets: (1) keep each glazing layer thin and (2) be sure the underlying layer is dry first.

Masking

I like to use masking fluid (specifically, Pebeo Drawing Gum) on my paintings to preserve some of the lights, so let's talk about when and how to use it. Used correctly, masking will prevent pigment from coloring your paper wherever it is applied. I often place it in the hair so I can paint like a wild woman and still have shiny areas. I might use it in the eyes or on the teeth as well, but usually I find it easier to just paint around those areas, keeping them dry.

Begin by stirring the liquid, removing any big chunks of solidified material. Don't shake the bottle—that creates bubbles. Next, apply the masking with an old brush you've rinsed first in mild, soapy water. You might also apply the fluid with a ruling pen. Ruling pens allow you to create long, thin strokes that look like wisps of hair. Your watercolor paper must be completely dry. Damp paper will adhere strongly to the masking fluid and come up when you remove it.

When first applied, Pebeo Drawing Gum is light gray and shiny. It darkens as it dries but remains slightly shiny. You can dry it with a hair dryer, but don't make the air too hot. Do not place the artwork in direct sunlight to dry—Pebeo will become one with your paper, never to be removed. You may leave Pebeo in place on your paper for about a month, but if you can't work on your painting for several months, take the stuff off. You can always reapply when you're ready to paint again. One final note: Pebeo will form a dam, allowing water and pigment to gather in big, sloppy blobs, just waiting to dribble across your drying art or crawl back onto an important part of the face. Watch for these dams.

Once you've painted your work, you can remove the Pebeo with your finger, a kneaded eraser, drafting tape or a rubber cement pick-up. You can create your own picker-upper by leaving a bit of Pebeo in a paper cup and allowing it to dry. Once dry, it works like a charm.

If you've applied heavy pigment over the top of your masking, watch that you don't smear the leftover paint across your art. Take a damp cotton swab and clean the pigment off the masking before removing it.

Masking, including Pebeo, leaves a sharp edge, which is fine if you want a sharp edge. Most of the time, though, you'll want to soften the edges between the white paper and the pigment. I use a Fritch scrubber, which is a brush with short, stiff bristles. I wet the brush, dab it dry and scrub from the white paper outward into the pigment. Rinse the brush, dab, scrub. Rinse, dab, cha-cha-cha.

Pebeo Drawing Gum applied on paper.

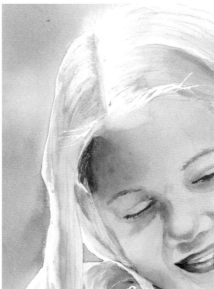

You can soften the edges of your masked areas with a stiff brush.

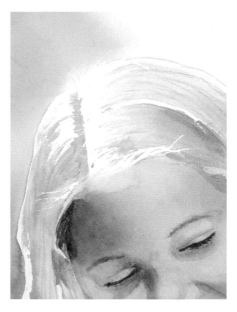

When the masking is removed, you'll have hard edges.

Underpainting

First, let's talk about what underpainting is. With watercolor, you paint from your lightest colors to your darks. With oils, you work from dark to light. Very few parts of a face are truly white; therefore, you'll want to lay down a pale wash to establish the underlying color (or underpainting). I determine the base color (pink, coral, yellow or orange, and always pale, pale, pale). How do you figure out the base color? Here's how I do it. Punch a hole in a scrap piece of watercolor paper and hold it over the lightest light on your subject's face. Make sample washes and compare them against this base color.

To apply the underpainting, wet the entire paper. Really, really wet. Big brush, lots of water. Dump the excess water off the paper and apply the base color all over the face and into the hair (you've put masking over the whites you want to save, remember?). You can avoid any area you want to remain white or put masking over the white of the eyes and teeth. Your color is pale enough that it shouldn't make a difference if you do accidentally go over a white area.

Glowing Edges

Glowing edges occur when the watercolor goes from dark to light gradually, forming soft edges rather than sharp edges. You will get an edge like this by adding a single stroke (preferably) of color while the paper is wet, but not sloppy wet, and allowing it to bleed outward.

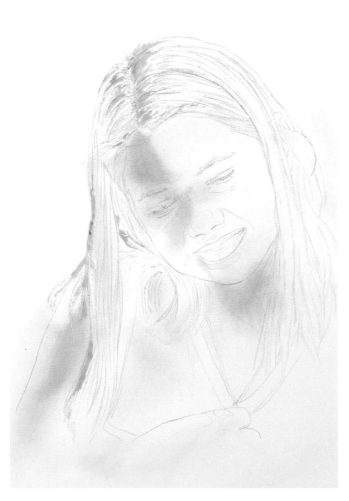

The underpainting is the general color forming the base skin tone.

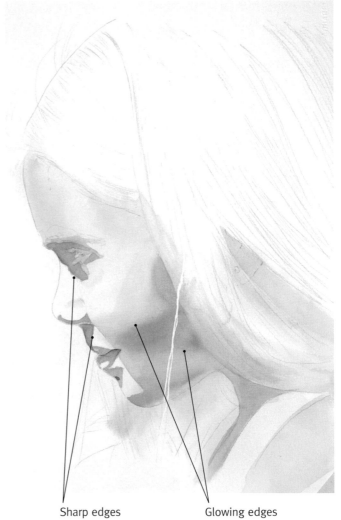

Sharp edges Glowing edges

Establishing the Darks

Get Brave, Get Dark

One drawback to glazing layer upon layer of light pigments is that you can end up with a very pastel painting. You're gonna have to get bold. Find an area that is quite dark on the photograph and get dark in that area of your painting. It's going to drive you nuts, looking at that big old blob of dark, but it will force you to adjust the rest of your values until those darks seem correct.

I see you sneaking in there with that paper towel to dab out the dark you just put in. Stop! Put the towel down and step back from the painting. Whew, that was close! The trick to putting in a dark is that it needs to be in a rather small area and in a place where you won't be painting much, because an errant wet brush over a dark will drag that deep pigment where you don't want it. In other words, don't paint all the hair black right away.

Negative Space

What's that? You might be thinking bad karma or Feng Shui. Nah, nothing so esoteric. In watercolor, we often paint the negative space or the space around the shape we're working with. If I were painting hair, for example, the first lighter colors are the final colors, and I'll paint the dark places (or negative spaces) in between.

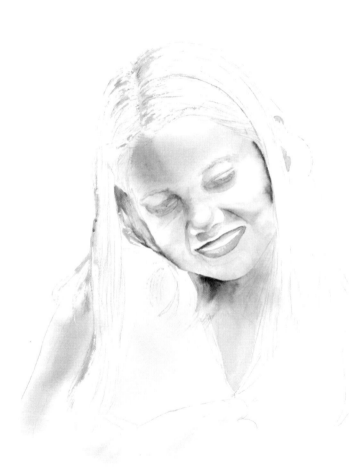

Be brave! Establish some darks early on to help gauge your values.

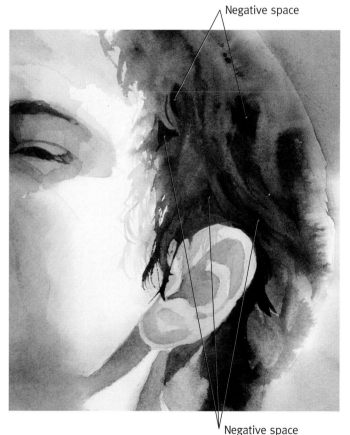

Negative space

Negative space

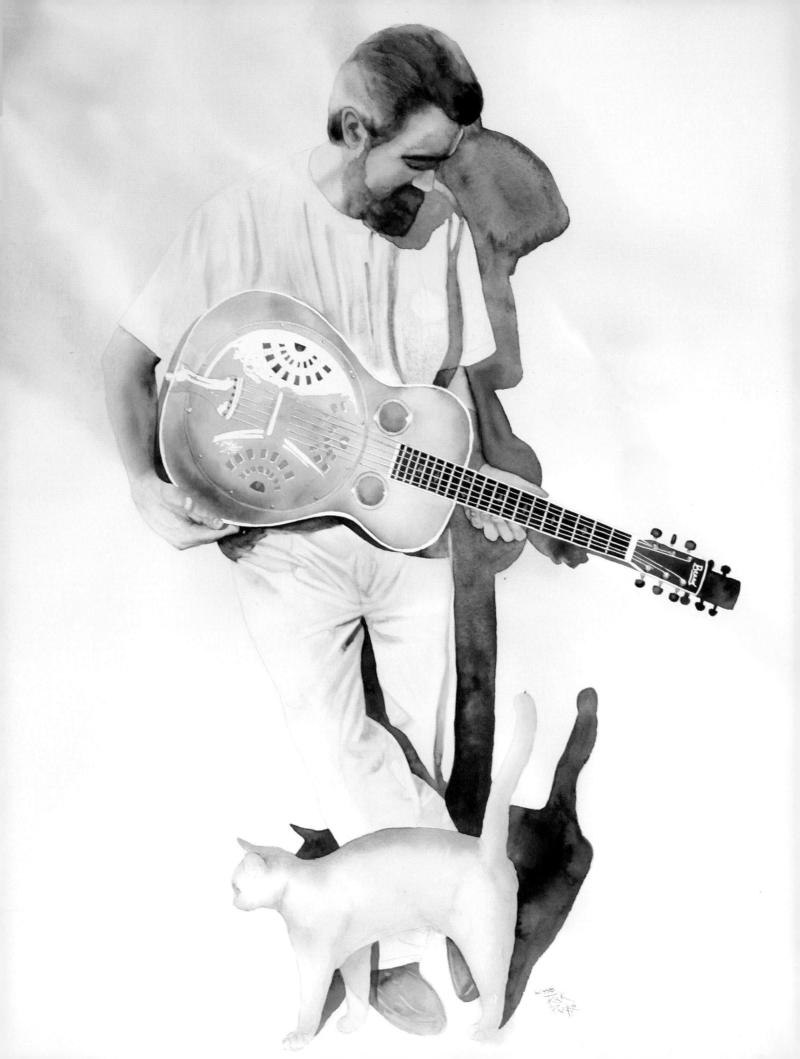

Chapter 3

Preparing to Paint

Watercolor can be as simple as grabbing a brush, swishing it in water, globbing on some paint and smearing it across a piece of watercolor paper. However, I will assume you wish to have your portrait recognizable as a human and possibly even as someone who can be identified. That will take a bit more planning. A good watercolor starts with a good drawing, the right tools and colors ready to go, and some thinking ahead (not a lot or I wouldn't be doing it!).

In the previous chapter we covered various watercolor techniques. We're going to build on that with new considerations. I plan on holding your (virtual) hand throughout this process. I realize you are staring at that big, blank, expensive sheet of watercolor paper and the terror is building. Don't worry—we'll make it. Really.

You've already chosen a photograph you want to paint. Not family. Nor friends. Clear, easy to see and fun. Okay, maybe not as much fun, but the other two points count. You will need to draw it on a piece of drawing paper. There are several ways to get the proportions correct that I will cover in the next few pages. Ready?

RICK, SELF-PORTRAIT
30" × 22" (76cm × 56cm)
Transparent watercolor on Arches 140-lb. (300gsm) cold-pressed paper

Using a Grid for Proper Proportions

There are several ways to correctly proportion a photograph into a drawing. The most common method is using some type of grid system. I create grid overlays on my computer by drawing 1-inch (25mm) lines using Adobe Illustrator, then printing them onto clear acetate sheets like the ones used with overhead projectors. If you want to go low-tech, an extra-fine-point permanent marker on write-on acetate sheets works fine. Be sure you firmly attach the sheet to the photograph so it doesn't shift. You have several options for the drawing paper: you may draw the corresponding grid on the paper or simply ink a grid, place it on a lightbox and lay the paper over the top. Don't have a lightbox? A window on a sunny day also works.

It's not critical that you draw a complete sketch before you paint. You just don't want to be figuring out the drawing on your watercolor paper. How much detail do you need? That's up to you. If I'm doing the drawings for my paintings, I have just a few lines. If my hubby, Rick, is doing the drawing, it will be very detailed. Almost all the drawings that underlay the watercolor portraits in this book are by Rick. No, I'm sorry, you can't borrow him.

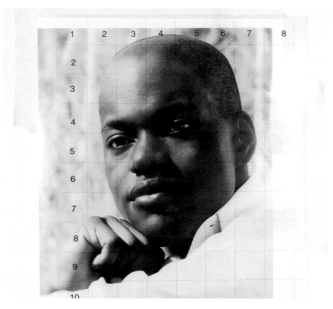

My reusable acetate grid is numbered up the side and across the top.

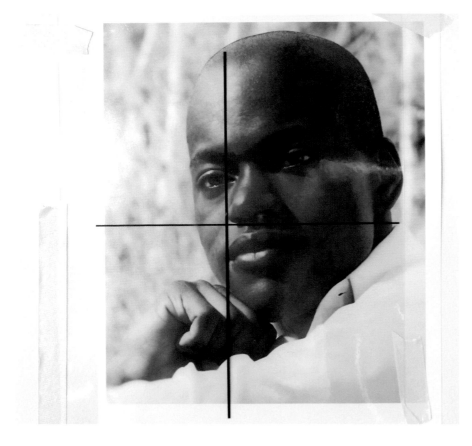

The purpose of the grid is to help you see relationships, so a simple two-line grid will work well.

Proportional Divider Tool

An additional tool you might find helpful is a proportional divider. It's usually metal with a screw that can be adjusted to allow you to measure two objects at once. Proportional dividers are an old drafting device and are expensive to purchase but well worth the money. Select a single feature to measure, such as the width of an eye, on both your drawing and the photograph. By sliding the screw back and forth, you set it so when you place it on the photo, it opens to the correct width on your drawing. Once set (by tightening the screw), anything you measure on the photograph is correctly scaled on your drawing.

Enlarging Details

I do have some great photographs for the paintings in this book, but often I'll need to enlarge details such as the pattern of color and light on the eyes, nose or lips. I'll enlarge any detail that I might need. I also might turn the original into a black and white image so the values (lights and darks) are clear. Before I begin to paint, the photograph is placed into a clear page protector to keep it safe from errant water or paint.

A proportional divider will help you scale your photograph into a correctly proportioned drawing.

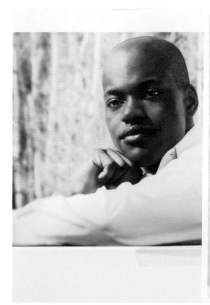

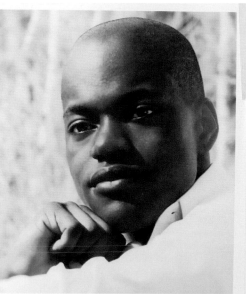

I'll enlarge details, often having a photo that shows just the eyes or lips.

Four Ways to Transfer the Drawing

I know I've mentioned it before, but your watercolor paper's surface is pretty fragile. You don't want to develop your drawing on it (unless you're doing life drawings) because erasing scratches up the surface and makes a mess. Instead, once you've done your sketch on a separate sheet of paper, you'll transfer it to your watercolor paper. There are several ways to do this: tracing paper, opaque projector, digital projector and graphite paper. Let's examine each method.

Tracing Paper

With this method, you place the tracing paper over your sketch, select the lines you want for your painting, then put the tracing paper on a lightbox or window, tape your watercolor paper over the top and trace. If you use a black pen to trace the drawing onto the tracing paper, the markings will show easier. Just be sure the black pen doesn't bleed through to your sketch.

Opaque Projector

These nifty devices are available in art supply stores. Though expensive, if you're doing a lot of painting, they are worth the price. They are called "opaque" because they allow you to project a photo or drawing onto your watercolor paper, in contrast to a slide projector that lets you view only transparent slides. Check the size of the copy area as the opaque projector limits the size of the final drawing you can make on your paper.

Digital Projector

Cutting further into your art budget is the digital projector. With this, you can take a digital photo of your sketch and project the image. Like everything in the digital world, by the time this book goes to print, there will be new products out there. Check around.

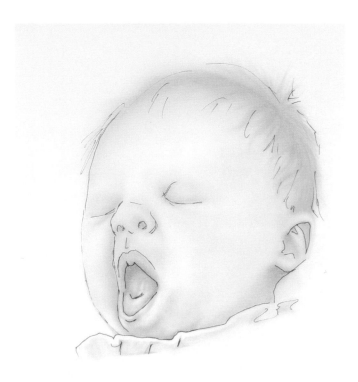

I purchase tracing paper in a roll. This is Bienfang Canary Sketching and Tracing Paper.

Watch out that you don't push too hard with your pencil in either the sketch or in transferring. You'll score the soft watercolor paper and end up with nasty lines.

Tip

Your watercolor paper is no place to erase those mistakes. Erasing can damage the paper's surface. Work out the image first on sketch paper.

Graphite Paper

You may purchase commercially made graphite paper, but I've found the surface to be a tiny bit waxy, which keeps paint from sticking in those areas. You can create your own reusable graphite paper. You'll need a big graphite stick (6B), a small rag, a piece of tracing paper and lighter fluid. Scribble on the tracing paper, then wet your rag with the fluid and immediately rub the surface. The lighter fluid melts the graphite into a thin layer. And there you have it! Graphite paper.

This is about how much scribbling you will need on the tracing paper to make your own graphite paper for transferring drawings.

After rubbing quickly with a rag dampened with lighter fluid, the scribbles merge, forming graphite paper.

Choosing Colors and Masking Off

You're still not quite ready to start painting. You'll want to make some more decisions before starting.

Choosing Colors

As your underpainting is the lightest light of the paper, you need to get the proper pigments on your palette. Take a scrap piece of watercolor paper, punch a few holes in it and place it over areas of the photo to get an idea of the colors present. This allows you to see the colors without all the distractions. Paint sample pigments on the watercolor paper to see if you're getting close. I find my lightest colors (other than white) and my darks this way.

Masking Off

So far you've sketched the art, transferred it to several sheets of watercolor paper, placed the photo in a plastic sleeve, enlarged any details and chosen your colors. Now is the time to apply any masking needed. Here is something to remember: when the masking fluid is removed, it will also remove pencil detail. Will you need this detail later? Will the fluid create havoc with the free flow of pigment? Will you change your mind later? Every little squiggly edge you paint with masking fluid will show up. Can you fix it? Straight lines are hard to keep straight. Make your decisions on what to save with masking fluid at the point when you're just about ready to begin.

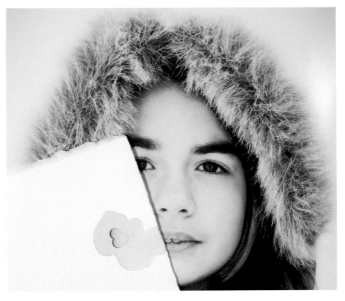

Decide your color palette by placing white watercolor paper with a hole cut in it over various areas of the photograph to help you see the colors.

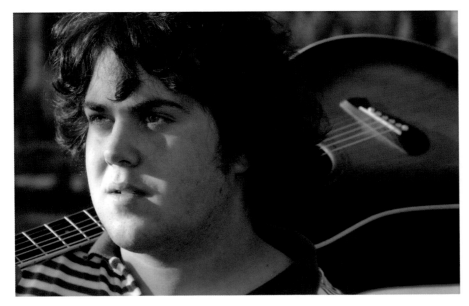

Masking fluid would be helpful used on the following areas of this picture to protect the lightest lights:
- Fretboard
- Guitar strings
- Highlight around sound hole
- Bridge
- Highlight in eyes
- Highlight on tip of nose

Practice

Once you have a drawing of your subject, don't limit your-
self by transferring it to a single sheet of watercolor paper.
I often have two or three sheets ready to go of the same
subject. If I goof up, all I have to do is start with another
piece. It's less pressure and means my work is that much
more loose and free. I'll also try out different colors, papers
and techniques.

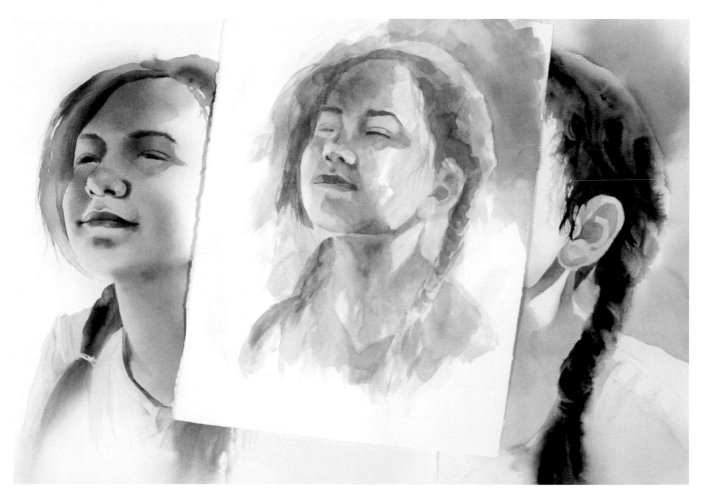

I've drawn and painted Courtney many times. Shown here are two paintings from the
same drawing: one on Arches 140-lb. (300gsm) cold-pressed watercolor paper and anoth-
er one on Arches hot-pressed paper. Different surfaces mean different handling of the
paints and techniques.

Tip

*Like the latest gizmos? Put your photo on an iPad. Just
a quick flick and you have it enlarged. And you will look
so cool!*

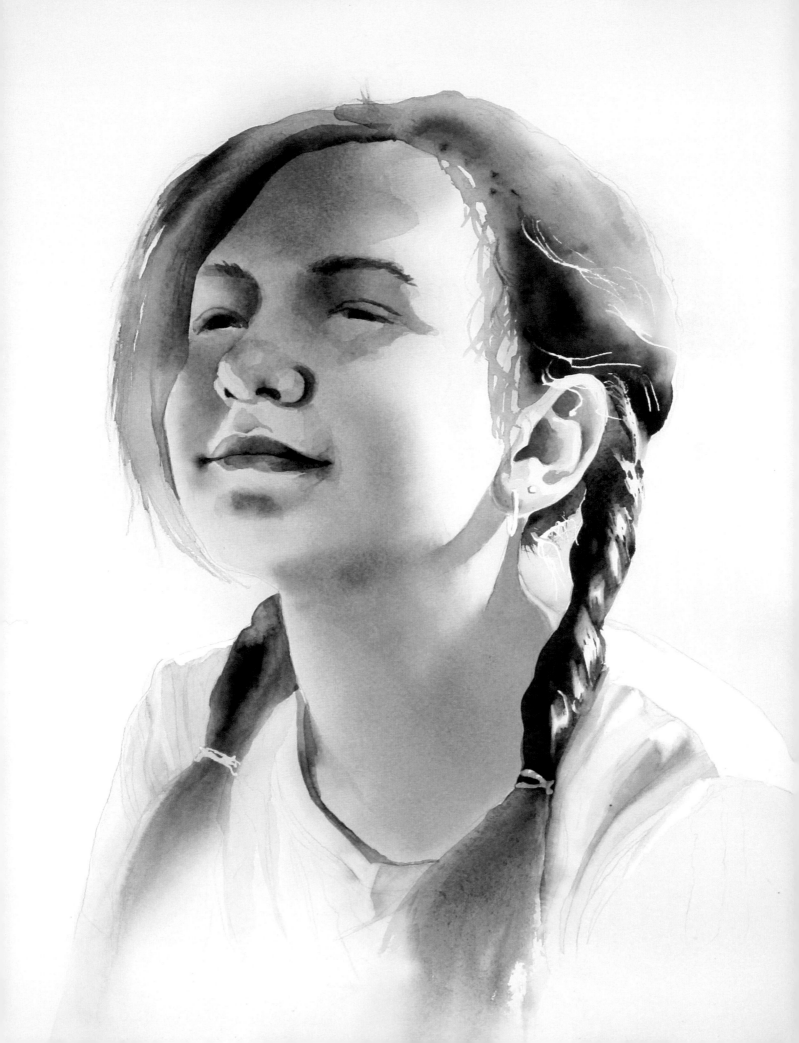

Chapter 4

Values, Shading and Skin Tones

We're now ready to jump into painting, right? I expect you to be a bit nervous if this is one of your first portraits. Be prepared to paint yourself in and out of problems—with learning the "out" part critical to the success of your art. In the last chapter we talked about the thinking and preparation for the work. In this chapter, we'll take a look at how to evaluate and convey the values (lights and darks) of your subject, especially the skin tones. Yes, I know, there's a lot of thinking and decision-making in watercolor—but it's all worth it when you see the results.

I like to paint a portrait where there's a strong light pattern. As a forensic artist, I don't get to do that often. (I mean, how arty is a mug shot? It's about as interesting as a driver's license photo.) The pattern will usually be one of two types: a sharp-edged shadow or a soft-edged or glowing shadow. With time and practice, you will get better at using value and shading to paint convincing portraits.

COURTNEY
22" × 22" (56cm × 56cm)
Transparent watercolor on Arches 140-lb. (300gsm) cold-pressed paper

Shadows and Edges

It's far, far easier to paint big watercolors than small ones. By big, I mean that I seldom paint a portrait smaller than a half sheet, or 15" × 22" (38cm × 56cm). I'm telling you this now because it does make a difference when you need to paint big, sweeping shadows. You have to keep the paper wet when you do this, and a larger sheet of paper is a tad more difficult to keep wet. You also want to keep the number of brushstrokes you use to a minimum as each stroke has the potential to lift the previous layers of dry pigment. I look for edges. Edges? Yep. I look for a place where I can stop wetting the paper and not end up with a line of pigment. Then I break up the painting into sections. Once I've painted the underpainting, I work on these sections. An edge may be formed by the hair (if the hair is dark, as you'll be painting over this part), eyebrows or a sharp shadow line.

Practice your strokes before painting. Left: You have too much water on the paper. Be sure you don't have any puddles of water that will creep into your pigment as it dries and then form blossoms or crawl-backs. Middle: Here you have just about the right balance of pigment-to-water for a lighter shadow. Right: There's too little pigment, usually caused by too much water in the brush or a watery puddle on your palette.

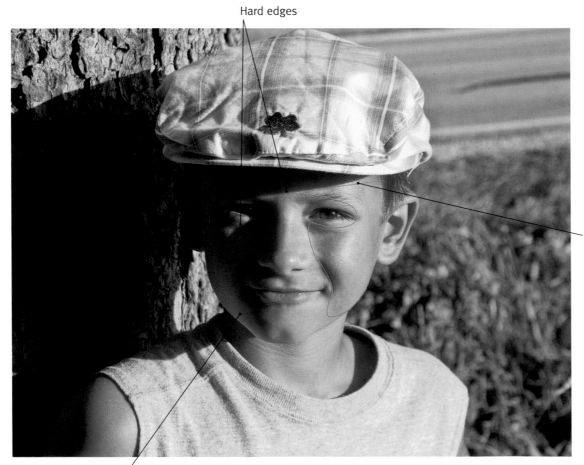

Hard edges

Stopping point for wetting the paper

Glowing edge

Shadow Colors

I confess I was going to do a whole series on shadows using my friend Dan. I started painting him with blue, green and Payne's Gray shadows. I couldn't finish. It was just too awful. Take my word for it, you don't want green, blue or Payne's Gray as a principal shadow color if you are going for more realistic images. Blue, combined with the slight orange of Dan's face, makes a lifeless gray. Green was just wrong in so many ways. Payne's Gray was dead. I ended up with just two paintings: one with the warm tones I usually use and another with a yellowish Burnt Umber. I think of the second as Dan-with-jaundice.

Now, please understand that you can create a fabulous painting with any colored shadow (well, maybe excluding Payne's Gray). Watercolorist Don Andrews does incredible figures with unconventional colors. Go ahead and give it a shot and don't let me hold you back.

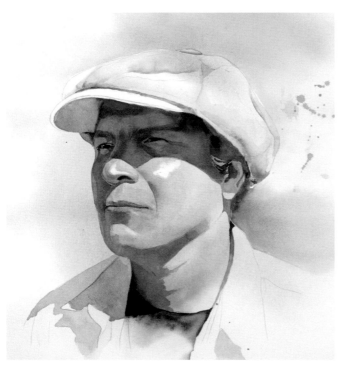

Dan with warm shadows created with a mixture of Cadmium Red Light, Quinacridone Rust and a hint of Burnt Umber.

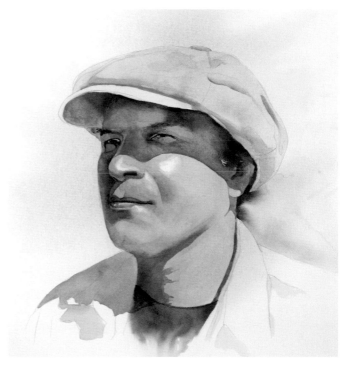

Jaundiced Dan. Skin tones are pushed too far into yellow, with shadows mostly Burnt Umber. I hope he stays a friend

Tip

Watch how you load your brushes with water, especially the expensive rounds that hold a lot of water.

Painting Light Skin Tones

This beautiful young lady not only has light skin tones, but she is also young, so overshading can age her. Additional challenges are her dark eyebrows, which can look like black blobs if I'm not careful, and the fur hat. I'll be working with very light to very dark pigments in this demonstration.

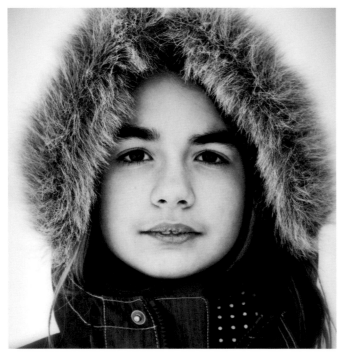

A beautiful photograph makes painting that much easier. This lovely young lady was photographed by Ernie Fischhofer.

Rick created a detailed drawing for my painting. What a guy!

Quinacridone Rust

Quinacridone Rose Cadmium Red Light

The colors used to establish the light skin tones are, clockwise from top, Quinacridone Rust, Cadmium Red Light and Quinacridone Rose.

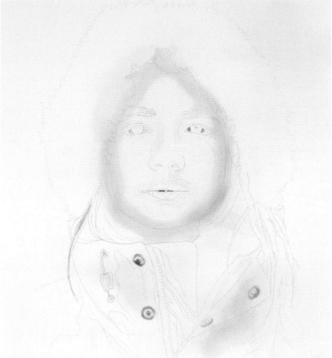

❶ Masking and underpainting

I masked off her teeth, the whites of her eyes, one strand of hair and the snaps on her coat. After the fluid dried, I wet the entire paper (wa-a-ay wet), dumped the excess water, then applied a pale wash of Cadmium Red Light, Quinacridone Rose and Quinacridone Rust. I painted the edge of her face a bit darker. I added an Anthraquinone Blue wash on her jacket and toward the top of her hat.

❷ Rewet and reapply shadow

I wasn't satisfied with the underpainting shadow. Even though she is light-skinned, her shadows have depth. As I didn't want to lift the first layer, I just wet the whole sheet of paper again with a spray bottle of clean water, dumped the excess and went around her face once again.

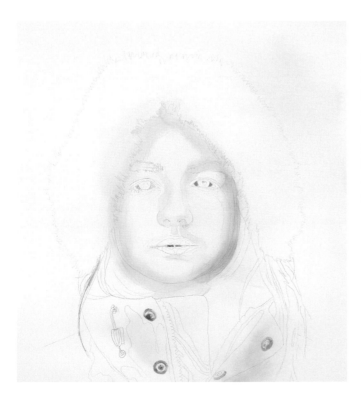

❸ Find the shadows

Once again, I wet around the face and darkened it, this time bringing the shadow across the top of the brow. I darkened the sides of and the space below the nose and under the lips. The color was diluted on my palette, and I made sure I didn't add any more water to the puddle by slightly drying my brush on a paper towel to remove excess water. I used a round brush as it will not lift paint as easily as a flat brush. I applied the color on dry paper, but had a wet brush ready to soften the sides of the stroke so there wasn't a sharp edge.

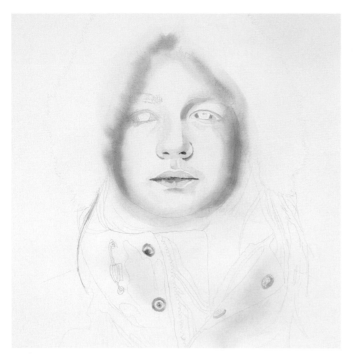

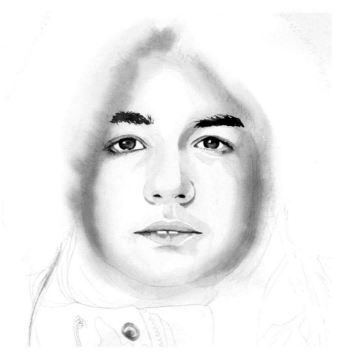

④ More darks and details

Each time I worked on her face, I felt the shadows on the sides weren't dark enough. I was going to be introducing some pretty good darks soon, and that's not the time to go back and try to adjust colors. I studied her face in the reference photo, looking for the details of where her face was light, dark and midtone. I worked on her lips, using Quinacridone Rose and Quinacridone Rust (more rose than rust as her lips are pinkish). Her nostrils are a blend of the colors I've already used plus Burnt Umber to make them dark. Notice how I work from big, overall colors to detail colors. Details come last.

⑤ The eyes

Her beautiful brown eyes capture the viewer, and I wanted to do justice to them. I removed the masking fluid there first to work on them. How to paint eyes is covered in Chapter 5, but you can see that the shadows, which seemed dark in previous steps, aren't all that dark when the dark eyebrows and eyes are added. I used a tiny brush and a dark mixture of Burnt Umber and Anthraquinone Blue.

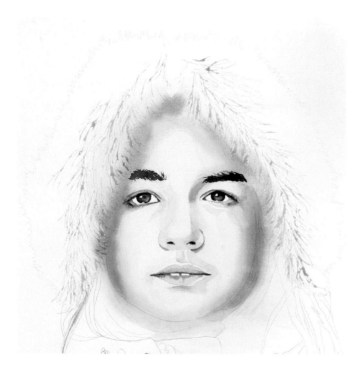

⑥ More masking fluid

There are times that fear and indecision will halt our painting. I rather like the painting so far. What if I mess it up? What if, what if? Say to yourself, "It's only a piece of paper. I can do it again. And again if necessary."

I liked the furry edge of her hat and had originally planned on ignoring the whiter bits of hair shown in the photograph, creating a darker rim to her face. However, I've changed my mind. I want the lighter hairs, so using a ruling pen and masking fluid, I placed a number of hairlike strokes around her face. I made sure the lines were very fine and lifted the ruling pen at the end of each stroke so the masking fluid tapered at the end.

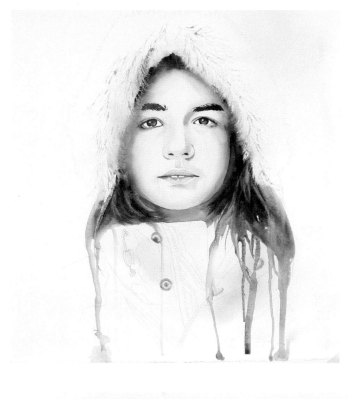

 The dark hair

The young girl's hair is more implied higher up on her face and doesn't really show until toward the bottom. I wet the paper around her face and down into her chin area with clean water. I used a lot of water, forming puddles. I wanted the hair to run. Just before I was ready to paint, I allowed the water to run off the paper. You need to work quickly now and with a tilted board. Using a large (no. 12) round brush and freshly squeezed pigment (Burnt Umber, Red Iron Oxide and Anthraquinone Blue), I stroked the hair downward and curving under her chin. Be sure you don't add extra water to the pigment; touch the back of the brush to a paper towel to discharge the excess water. I used a wet clean brush to soften the color around her face. A 1-inch (25mm) flat brush will lift pigment and break up the bigger chunks, implying strands of hair.

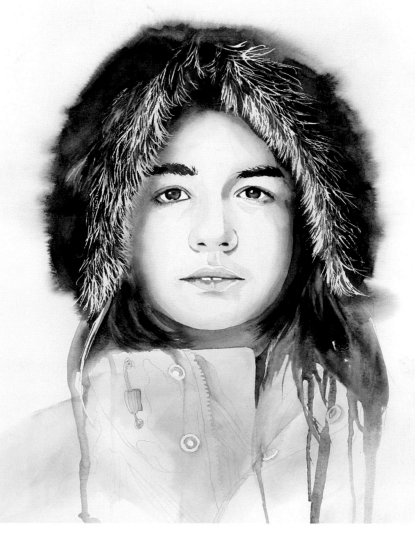

8 Furry hat and finish

Ready? Get those deep colors out and freshly squeezed onto your palette. I used the same three colors as before: Burnt Umber, Red Iron Oxide and Anthraquinone Blue. I wanted the red to warm up the other colors. Wet the hat and all the way to the end of the paper all around her face. You can even wet a bit below the hat. Dump the excess water; we want the paper very wet, but absolutely no puddles. Make sure your brush does not have extra water in it as well. Load the brush with all three colors at once. Make your first stroke near the masked area to see how far it will bleed. You can adjust the pigment/water ratio if it bleeds too much. Work quickly. Don't panic if some of the pigment starts to drift across the paper; a wet flat brush (damp, but not adding extra water) will clean it up.

Once this dried, I lifted the remaining masking and blended some of the white hairs into the hat. You don't want to see both ends of a line—hair comes from a darker source. A slight wash over her coat and I'm done.

Painting Medium Skin Tones

This handsome fellow is Sgt. Rick Perez of the Port Hueneme Police Department in California. He's a dear friend, wonderful artist and brother in Christ. I asked him to pose during one of our forensic art classes and he graciously agreed. He did request to be on the book's cover and for me to make him look like Antonio Banderas. I ignored him.

When you're painting black hair, you need to be sure the darkness of the hair doesn't make the skin look too light. It took me many layers to build up to the correct tones.

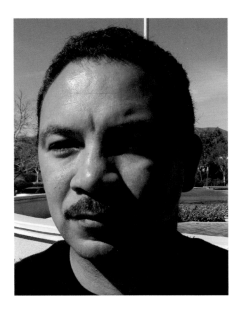

I lightened the reference photo on my computer so I could see the details in the shadows.

The colors I used for Rick's skin tones are, from left to right, Quinacridone Rose and Quinacridone Rust.

① Laying the groundwork

Rick has some very white areas on his face and hair. I placed masking fluid down his nose and on his eye, mustache, forehead and hair. After that was dry, I wet the paper (really wet), dumped off the excess water and painted a pale underpainting of Cobalt Blue in the hair, Olive Green on the shirt and a mix of Quinacridone Rust and Quinacridone Rose on the face.

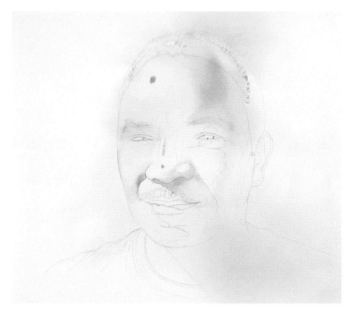

❷ Carving out shadows

I rewet Rick's forehead and applied more color to darken the shadow side of his face. After drying the area, I wet from the edge of the nose to the mouth on the left side and allowed the color to bleed outward to the cheek. The shadows under his nose, around his right eye and on the cheek received more color.

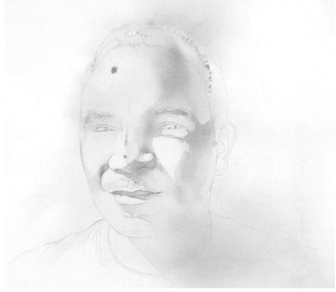

❸ More shadows

The shadows will now fall into two categories: hard-edged or soft-edged. The hard-edged shadows, like the one extending down Rick's neck, simply mean the paper is dry on the light side of the neck and wet on the shadow side. I wet way beyond where I think I should to keep a funky line from forming. The soft-edged shadows, like the one on his forehead, mean that I'm wetting all the way across the forehead, but applying pigment on only one side.

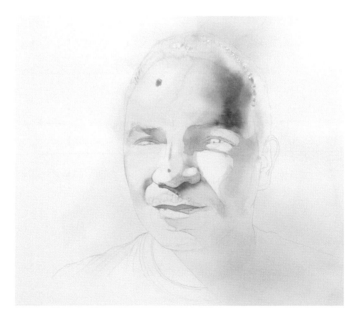

❹ The "eek!" moment

The "eek!" moment came when I decided to punch up the darks. I dove into a mess of Quinacridone Rust and Burnt Umber, then threw a purplish shadow under his nose and around his left eye. I'm glad at this point that Rick lives thousands of miles away.

Brushwork Tips

- *Use a round brush most of the time as it's softer than a flat.*

- *One stroke! You're not painting your bathroom.*

- *Touch the ferrule end of the brush to a paper towel to discharge excess water.*

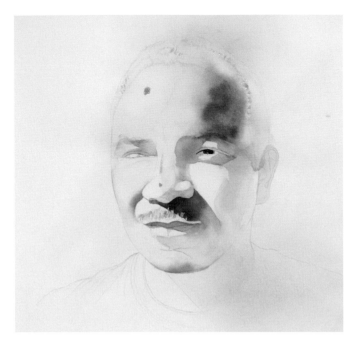

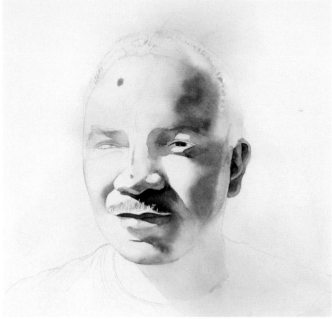

⑤ Pushing the darks

To keep from bursting into tears because of my "eek!" moment, I threw in more darks, this time under the nose. I tend to paint the eyes last, but figured you weren't as used to the blank-eyed zombie look as I am, so I added a dark to his left eye. I also added a dash of pigment on his chin and ear.

⑥ Varying the colors

With the exception of when I lay in a dark for contrast, I tend to glaze pale layers and build up the pigment. By working slowly, I can push the color more to the oranges, yellows, purples or browns if I'm drifting too far in one direction. Rick's mustache and the shadow directly under his nose are very dark, so I mixed a bit of Anthraquinone Blue with Burnt Umber to build up these darks.

⑦ Washing over the darks

After the paper was dry, dry, dry (as in waiting overnight) and using a soft round brush, I painted a unifying glaze of Quinacridone Rust and Cadmium Red Light over the left side of Rick's face. I'm also starting to work on the details at this point, such as his mustache and mouth.

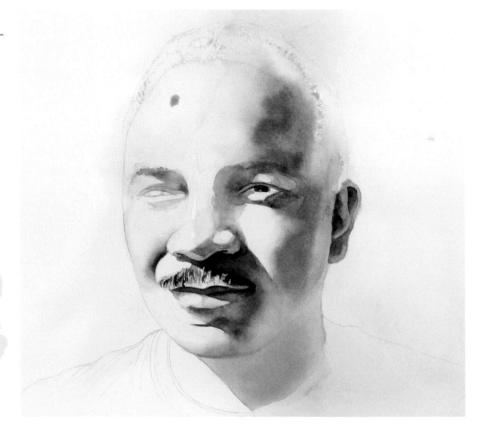

Tip

Your first brushstroke is your best. Don't abuse your paper by hammering it with your brush.

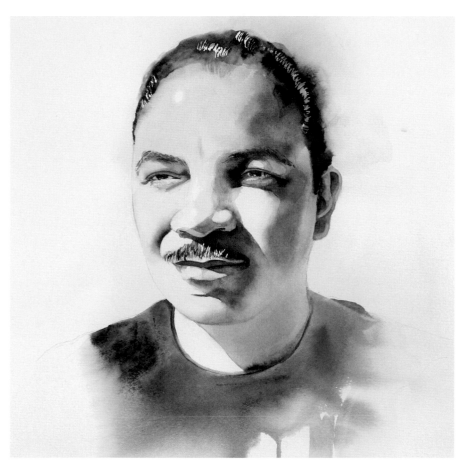

⑧ Finishing up with details

Rick's hair was painted with a mixture of Sepia, Anthraquinone Blue and Burnt Umber. I wet the hair area a bit farther out on his left side so his hair had a looseness to it. His eyebrows and eyes were painted with the same mixture and an absurdly small brush. His shirt is Olive Green and Anthraquinone Blue. I removed the masking fluid and softened the sharp edges in the forehead, nose and some of the hair.

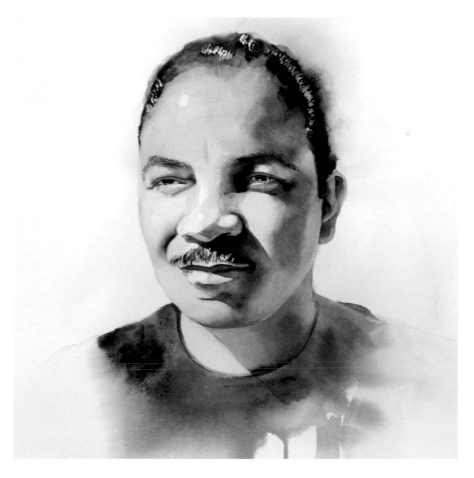

⑨ Too light

After letting the painting sit for a day or two, I decided Rick's skin looked too chalky in the light areas. This can be really tricky to correct. I carefully and quickly brushed a very thin layer of Quinacridone Rust and Cadmium Red Light over all of his skin.

Painting Dark Skin Tones

Carolyn is a friend, a gifted artist and for many years my highest-scoring forensic art student. A former detective, she is now retired from the Portland, Oregon, Police Bureau. Her beautiful skin and cheerful mugging for the camera made this a must-paint opportunity.

After punching a hole in a piece of watercolor paper and doing sample washes, I determined the base color of her skin was a mixture of Quinacridone Rust and Transparent Red Iron Oxide. The challenge was to get the depth of color without creating mud.

For this demonstration, I made an executive decision to not stop and take a photograph every single time I layered the color. If I had, there would be dozens of steps and the entire book would be devoted to Carolyn's portrait—not that there's anything wrong with devoting the book to my friend. We'd just have to change the name to *Secrets to Painting Carolyn.*

Reference photo of my friend Carolyn

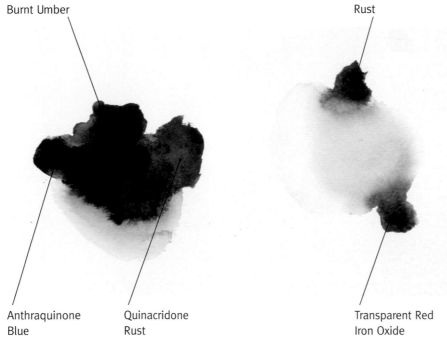

Burnt Umber

Quinacridone Rust

Anthraquinone Blue

Quinacridone Rust

Transparent Red Iron Oxide

The colors I used for glazing in layers were Quinacridone Rust, Transparent Red Iron Oxide and Burnt Umber. I added a smidge of Cadmium Red Light and Maroon Perylene. To darken, I mixed in Anthraquinone Blue.

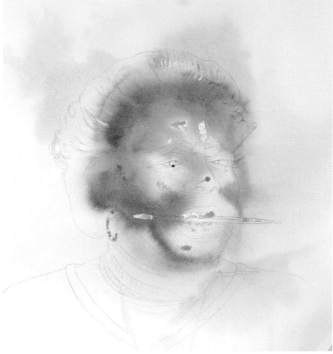

① The drawing

Rick, as always, created a detailed drawing for me. As he likes to say, he does the drawing, then erases the numbers when I'm finished painting. It's a wonder we stay married.

② Masking and underpainting

I confess: for much of the painting process in this demonstration, I scared myself at every turn. Light skin tones are fine—you can sneak up on the depth of color. But here, to create the darker, richer tones, I had to be bold from the get-go. I masked off the lights I wanted to save, then wet the paper and went wild with Quinacridone Rust, adding Burnt Umber on the left side of her face and diluted Cobalt Blue around the figure.

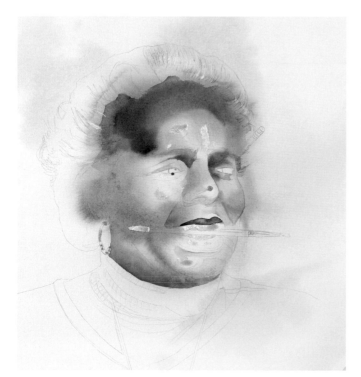

③ First layers

I needed to get a few darker areas going right away. I stayed with Quinacridone Rust on the temple and mixed in Burnt Umber to darken under her chin, under her lip and above her right eye. I stroked Cadmium Red Light with Burnt Umber onto her upper lip.

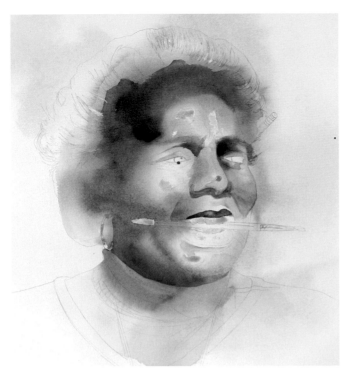

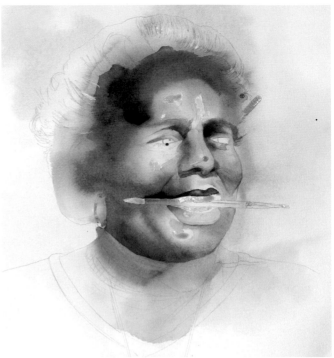

④ Building values

The deceptive thing about watercolors is that when it seems you've gotten really dark, you haven't. The darks on the face were almost black, yet I was still tiptoeing around. Yeah, I was scared I would go too dark and mess it up, but that's why I always have more than one drawing at the ready. Here I added Anthraquinone Blue to the Burnt Umber to darken it more. I rewet the paper from the chin to the forehead and added more Quinacridone Rust mixed with Burnt Umber.

⑤ Looking for darks in all the right places

By this stage, I decided to not add any more color to the paper on the left side of her face, so I glazed washes to separate her face from the background. I also identified a dark area by the corner of her upper lip. I wet the paper as far as her nose and cheek, then applied the mixture of Anthraquinone Blue and Burnt Umber with very little water in the brush.

⑥ Details and more darks

At this point I decided to work around her mouth and removed the masking from her lower lip and teeth. The lips were a vast number of reds from Quinacridone Rose to Cadmium Red, plus purples. The shadow was a purple made from Quinacridone Rose and Cerulean Blue. I once again darkened both sides of her face and added yet another dark under her chin and other shadows.

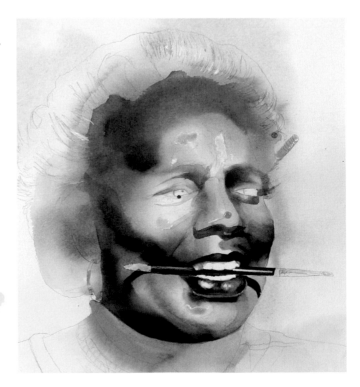

Tip

At times your portrait may look like a raging disaster. I'll pass on a great secret: Don't ever let a friend see their portrait while it's in progress.

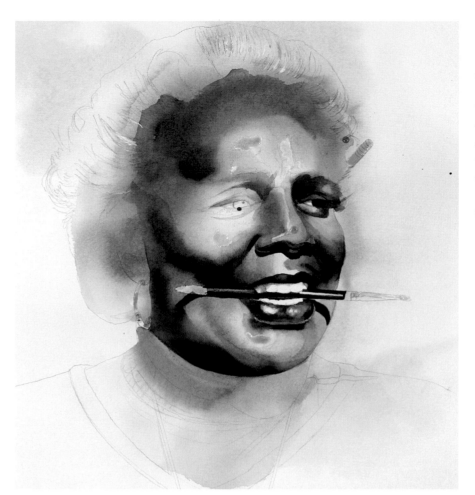

 Adjusting

Now that the mouth was close to the darkness I needed, I did a wash over the left side of the paper. Two things to keep in mind: Use a soft round brush and try to make it in one stroke. I painted on dry paper, but as soon as I placed the pigment, I had a wet brush waiting with water to smooth the outer edge. I painted the eye with no highlight at this point.

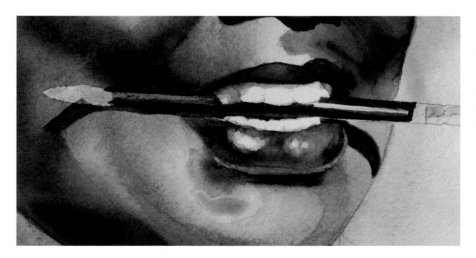

8 **Lips, close up**

Lips are not just one color. They vary with pinks, reds, burgundies and purples. I literally kept my finger on the reference photo and found each variation. Once I removed the masking fluid around the mouth, I softened the sharp edges with a small stiff brush.

⑨ Add an eye and blend

I painted her right eye and removed the masking so the white highlights show. I then placed a matching white highlight in her left eye, using Titanium White Opaque watercolor. More darks were needed to make her eyes deep enough. Her forehead on her left side seemed too light, so I did a swish of Quinacridone Rust with a soft brush on dry paper, adding water immediately with a clean brush to blend the edge. I didn't worry about the hair-side as this would be covered by her black hair. Her chin received another stroke of color as did the area around her temple.

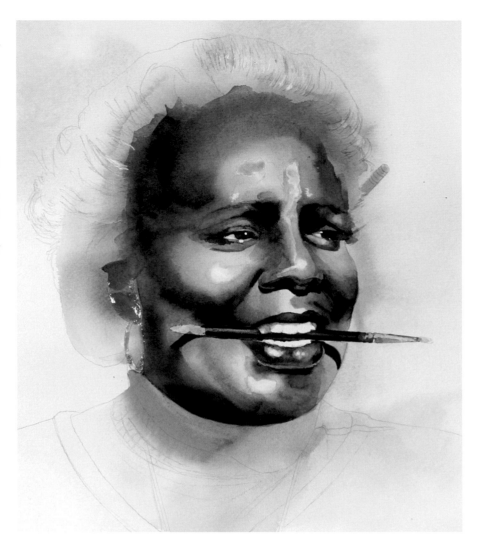

⑩ Hair thriller

The way I paint hair is like taking a roller-coaster ride. Yeeee-haw! I wet the entire hair area, including her forehead on her right side. I used a spray bottle to wet outside the hair area in a few places. Now lean closer and I'll share a secret: the paint has to be *thick* with very little water unless you want the pigments to fly all over. I dumped excess water so the paper was damp with no puddles. I used Indigo, Burnt Umber and a smidge of Quinacridone Rust. I didn't sweat the hairline on her right side as I can fix it later. I set out to do all the hair, but ended up doing just part of it.

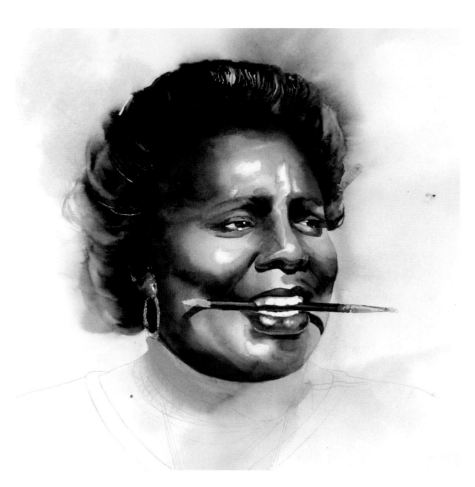

11 Finish hair and blend

I just know a few of you with pastel experience are looking for a paper stump to blend your colors. When I say blend, I'm talking about adding more water to an area with a soft round brush, making sure you're just making the paper wet, not creating soggy puddles. You then add more color or simply swish your brush back and forth once or twice to let the pigments run together. I lifted some highlights out of her hair with a flat brush.

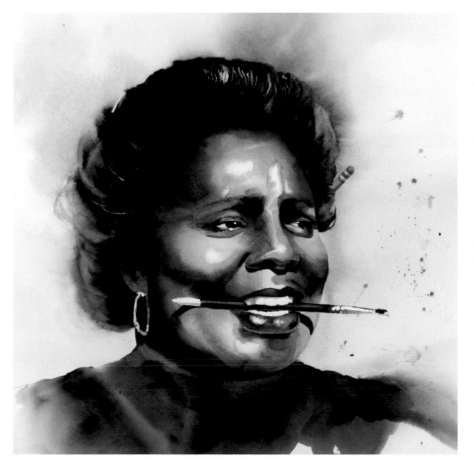

12 Finish and fix problems

I realize most folks want to fix problems as they occur. I tend to leave them until the end, and by then they may no longer be problems. I found I'd made Carolyn's hairline too far out, so I fixed that with a dark wash on her right temple. I didn't like the blue halo next to her hair on the left at the bottom, so I scrubbed it out a bit. I'd managed to dribble quite a bit of paint, so I just added more dribbles so you'd think I did it on purpose. Carolyn's clothing is just suggested with soft washes.

©1999 Carrie Stuart Parks IWS

Chapter 5

Drawing and Painting Facial Features

A well-painted face contains the facial features placed in the correct proportions and with the proper values (relative lights and darks). If you've never really studied facial features, except to note the dreadful lip augmentation on some famous actresses, you need to pause a moment with me and review them. Although this is a watercolor painting book, you need to be sure the drawings you make are accurate before applying any pigment, assuming you want your painting to capture a true likeness. If you are going for figure painting where the identity of the model isn't important to you, this chapter will still help you with correct proportions of the face and features. But a word of caution: After reading this chapter, you may never be able to look someone in the face again without staring at their nose and wondering why you never noticed their flaring nostrils before.

CORRINE
15" × 11" (38cm × 28cm)
Transparent watercolor on Arches 140-lb. (300gsm) cold-pressed paper

The Eyes Have It

Let's just look at a pair of eyes and get an idea of what we're viewing. I'm using a child's eyes for this example. Children's eyes differ from adult eyes in that the pinkish area on the inside corner, the medial canthus, is smaller than an adult's, and the iris is larger compared to the whites of the eye. For the points I want to make, this little boy's eyes will work fine.

1) Even if the highlight appears in the center of the iris, move it to one side or the other. Otherwise you'll get a blank expression.

2) The upper lashes usually grow downward on both the inside and outside edges.

3) The lashes mostly show as a dark edge across the top lid. Only a few very long lashes show as individual hairs.

4) The lower lid is a shelf. It's usually light in color, not a big black line. The lower lid is best seen on the outside edge.

5) There is often a white dot or short line where the iris touches the lower lid.

6) Seen from the front, the iris is perfectly round.

7) The whites of the eye often have a slightly pinkish, purplish or bluish tint. A few are slightly yellow (slightly—watch out that you don't make them look jaundiced).

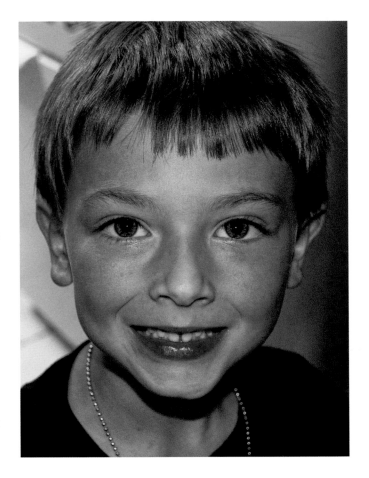

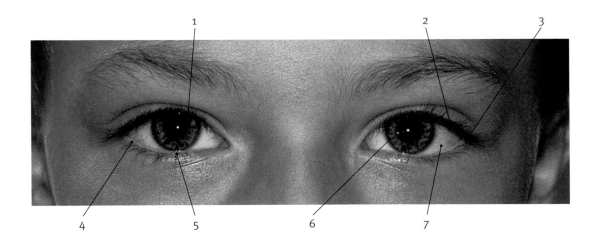

Here's Looking at You

Below are some of the different characteristics of eyes that can affect how they appear. In addition, eyes can have a combination of several traits.

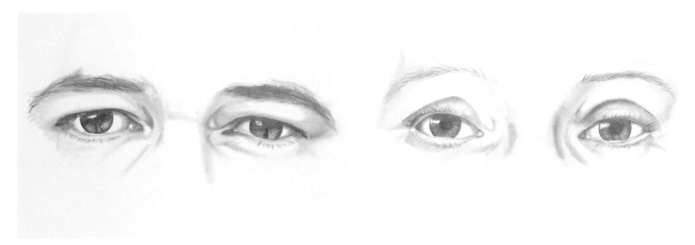

Overhanging lids

This is apparent when someone opens their eyes and the crease above the eye disappears. Folks can be born this way or it may occur with age. (Share the good news)

Heavy lids

Sometimes called "sleepy eyes" or "bedroom eyes." Eyes are usually called "heavy" when the upper lid from lashes to crease is wider than average.

Deep-set eyes

Often the eyes are deep set if the eyebrows appear close to the eyes. With deep-set eyes, you'll usually find lots of shadows between the eye and eyebrow.

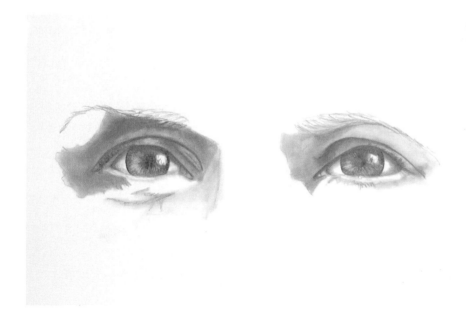

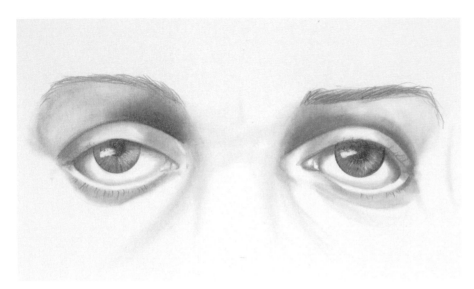

Raised iris
This usually doesn't mean the iris is actually raised, only that you can see the whites of the eyes below the iris.

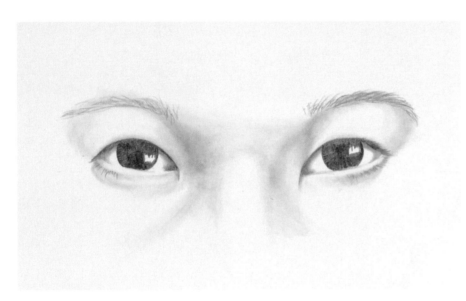

Epicanthic folds
This particular trait occurs when a skin fold of the upper eyelid partially covers the inside corner of the eye, the medial canthus.

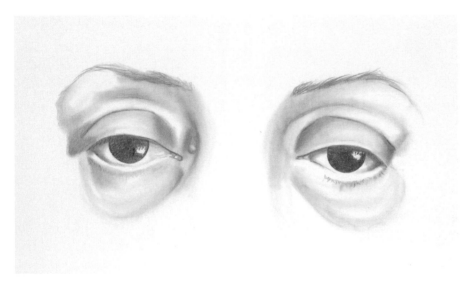

Combination of characteristics
This example combines a raised iris with a heavy lid. I personally love it when I get to combine various traits. They're so much more interesting to paint than average eyes.

The Iris

Let's separate out the iris and pupil and take a good look at them (I would say "let's eyeball them," but that makes even me groan). The iris is the colored part of the eye, with the dark pupil in the center. I'm painting a blue eye below, but the technique works for all colors. There are some cautions and tricks to painting the iris.

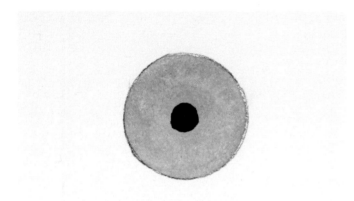

What not to do . . .
The most common way most folks paint a blue eye is to just paint it solid blue and place a black circle in the middle, making the eyes seem like those on a porcelain doll—the cheap kind. I'm expecting more of you.

What to do . . .
If you are going for a more realistic painting, you'll need to be sure the iris is round when viewed from the front, and the pupil is centered in the iris. You'll do this on your drawing using a circle template.

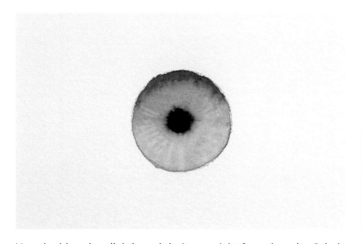

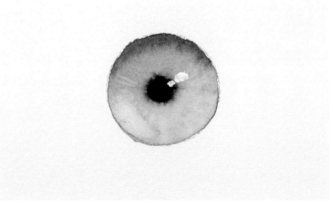

Vary the iris color slightly so it isn't a straight-from-the-tube Cobalt Blue, and place the pupil while the paint is still slightly wet so the edge of the pupil bleeds slightly, making it softer in appearance. Watch that you don't add extra water when you touch down your brush!

Add a highlight with a dot of white gouache, or put a dot of masking fluid there before painting to save the white of the paper. You can also lift the color on the iris slightly with a wet brush to create a glow. Be sure the iris is dry before lifting.

Degree of Detail

It's up to you to decide how much detail you want to put in your paintings. A few strokes may fully define the feature, or you may want to add considerable detail.

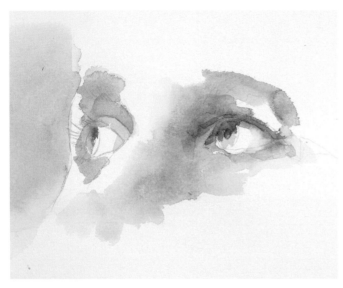

Loosey-goosey
Have fun and see how much you can define a facial feature with just a few strokes.

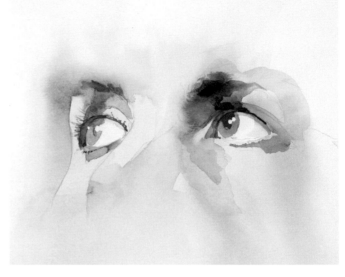

Loosey-goosey with a bold touch
Slap a few darks in a brazen color on your work. Now that's fun!

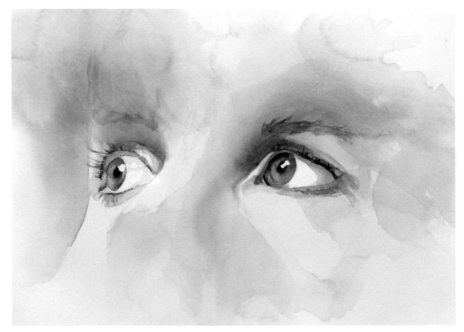

Paying attention to detail
This requires a more careful application of paint. It's your call and your art. Choose the look you like.

Painting the Eyes

Let's work through a pair of eyes. I painted this lovely young girl's eyes earlier in this book, and as you may recall, they provide a bit of a challenge in their darkness compared to the lightness of her skin. You'll want to start with an accurate drawing.

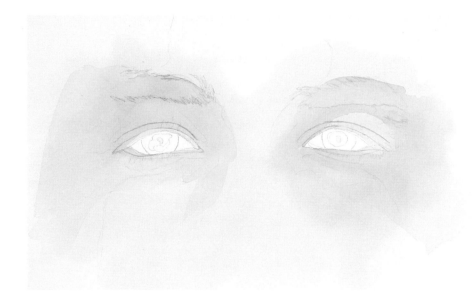

❶ Underpainting

I'm painting on a large sheet of paper and am demonstrating only the eye area here, so I just left the whites of the eyes dry, then really wet the rest of the paper. Be sure you dump the excess water. I made the underpainting (a combination of Quinacridone Rose and a hint of Quinacridone Rust) a bit darker around the eyes compared to the nose area, which will be light.

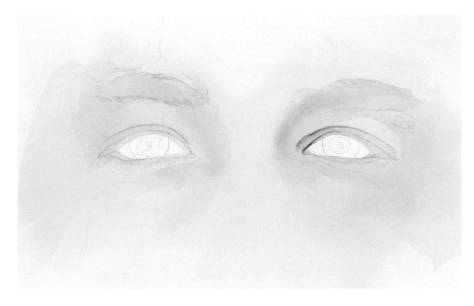

❷ Dry and layer

I can't emphasize enough that you need to make sure your paper is completely dry between layers. "Dry" means room temperature or warm to the touch. If you feel any coolness, the paper is still slightly wet, and the underlying layer will lift or blossom. Here I've started working on the left eye by adding a dark, soft wash between the eye and nose, and on dry paper I darkened the crease and upper lid in the inside corner with Quinacridone Rust.

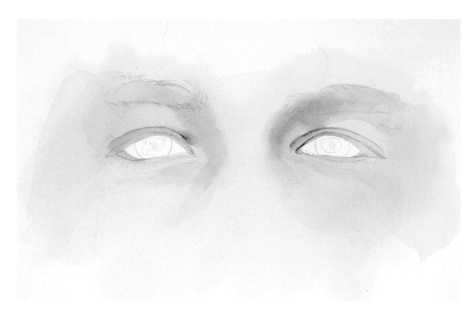

③ Change pigment

I've darkened the right eye, but this time with a slightly different color, going with more of a rose tone. I can go back and forth between colors this way, adjusting as I go along to be sure the skin tones don't get too red or orange.

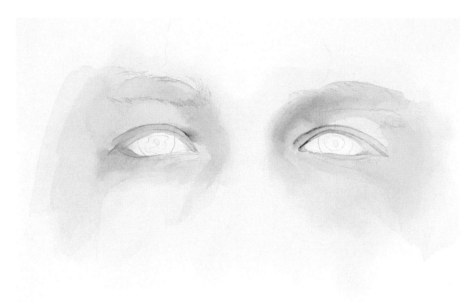

④ Look for subtle value changes

I've now layered more around the eyes: on the upper lids, between the eyes and eyebrows, around the outer corners of the eyes, and between the eyes and the nose. The painting is still quite light, and I may have to redo these areas several times once I put in the darks. It's always easier to add another layer than to try and lift a too-dark layer.

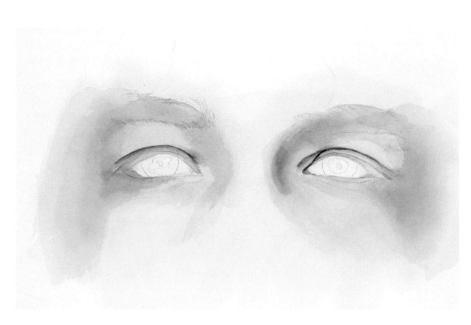

⑤ Gauge the amount of dark

The eyelids, which I started with on this layer, are quite dark. Using Burnt Umber mixed with Cadmium Red, Quinacridone Rust and some Cerulean Blue, I drew the eyelid crease. It was immediately apparent that all my values were way too light. I darkened the same areas as in step 4 above. Working quickly, I brushed on the pigment; then, using a brush with just water, I softened the edges so it wasn't a shape boundary. I added a very pale Cerulean Blue wash to the whites of her eyes.

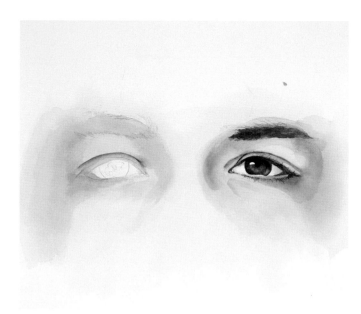

⑥ Then a miracle happened . . .

I know, there's a huge jump from the previous step to this one—or so it would seem. This is one of those times when if I had stopped to photograph it in progress, I would have botched it up because I'd have lost my momentum. Don't worry, I'll talk you through it. I painted the iris by using Burnt Umber with a bit of Anthraquinone Blue to make it even darker. I didn't paint the entire iris, only the outside edge. To start building dimensional roundness, I painted Cerulean Blue right away in the middle of the iris. While that was still wet, I added more Burnt Umber/Anthraquinone Blue to form the pupil, then let the whole mish-mash of colors bleed together. I painted the upper and lower lashes, making the hairlike lower lashes with a fine brush. With these darks in place, I adjusted the inner and outer corners to make them the correct dark-ness. Next I placed a gray-blue light wash to make it look like the upper lid was casting a shadow. I darkened the top of the iris using the same umber/blue combination. I let the whole thing dry, then added a couple of swipes of white. Finally, I lifted the brown outer edge of the iris opposite the highlight to create the roundness of the lens.

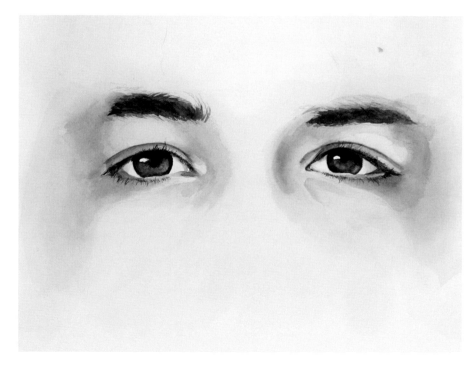

⑦ Finish

One of the big secrets of painting faces is that every time you think you've gotten dark enough, you'll find that you need to go even darker later. That was the case here. Go back and look at some of the earlier layers in the previous steps. You'll see that I still had to put more layers down once those black lashes and eyebrows were painted in. The eyebrows, by the way, were painted as large, dark worms, with the hairs added last with a very fine brush. Can you see the sharp-edged, bluish shadow on the right eye, at the outer corner as well as inner corner? That was a detail I needed once the lashes were done. Be very careful when placing a shadow that you do so with one stroke and very little pigment or water, or you'll bleed the lashes.

The Nose

I have no idea why some people feel that noses are such a challenge to paint. They are fairly simple, mostly value changes. You have the tip, wings, bridge, nostrils and sides. So let's take a look at noses and the characteristics that make them unique.

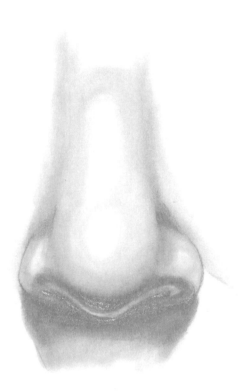

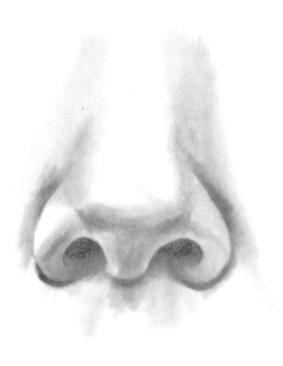

Oval nostrils, average oval wings (the part that flares out over the nostrils), tip of nose turned slightly downward.

Round nostrils, average round wings, tip of nose turned upward.

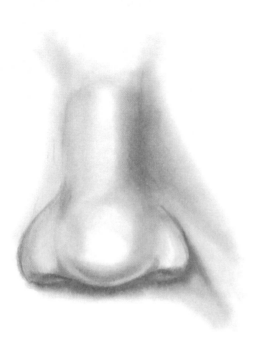

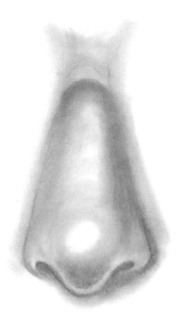

Oval nostrils barely visible, average oval wings, slightly concave from bridge to tip.

No wings, nostrils barely showing.

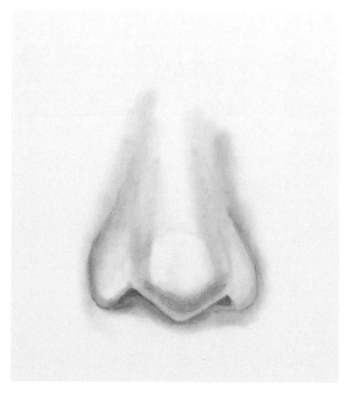

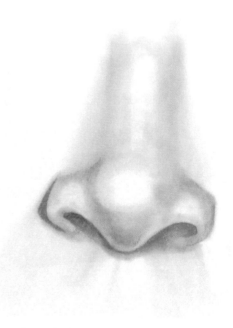

Triangular nostrils, wings not overly developed, tip of nose level.

Oval nostrils, oval wings, more concave from bridge to rounded tip.

Degree of Detail

You can paint a nose with only a few strokes or with greater detail. Here I've painted the same nose both ways. Pay close attention to the amount and depth of shadow on the nose. Children and babies have soft or even no shadows around the bridge of the nose.

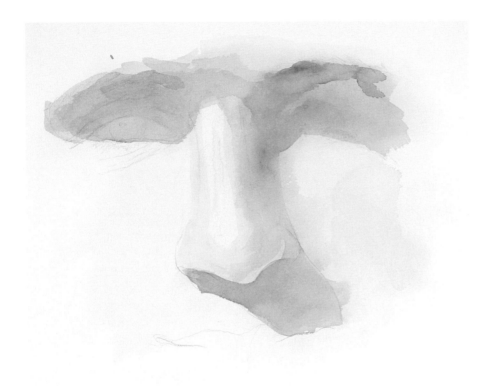

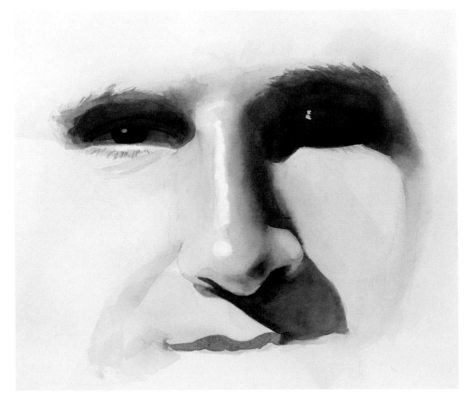

Detailed layering of a nose. I couldn't see the eye on the right, so it's just indicated here.

Painting the Nose

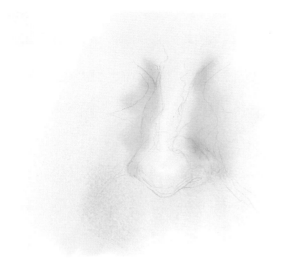

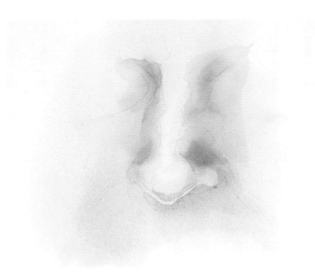

① First wash

Before painting, I determined the base color of the lightest light outside of white on the reference photo. As this nose didn't have any shiny white areas, I didn't bother with masking. I wet the entire sheet of paper, then dumped the excess water. I applied a pale wash of Cadmium Red and Quinacridone Rust over the area, and while it was still wet, I added a bit more paint on either side to start shaping the nose.

② Rewet and repeat

I want some soft edges (the sides of the nose) and some sharper edges. The soft edges require wetting well beyond where I want the pigment to end up. You can use a spray bottle or just keep a wet brush handy to soften edges. Be sure there isn't any extra water in your brush.

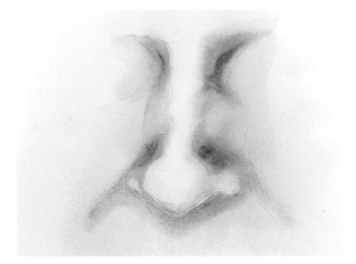

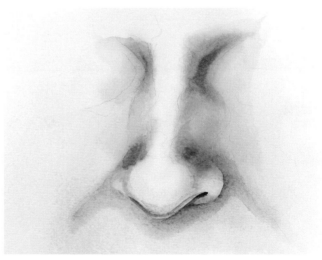

③ New layer, change of color

The colors were getting a bit too rusty, so I added blue to brown out the tone. There were some pretty good darks by the eye area and on the top of the wings, so I built up those areas. Keeping the tip of the nose dry, I wet below it and added more pigment.

④ Details

Remember I said noses are pretty simple to paint? Once the darkness on the sides and below the nose is where you want it, take just a few strokes to finish details such as the nostrils. Use a red-toned dark, rather than something like Payne's Gray, for the darkness in the nostril.

The Lips

The dividing line of the upper and lower lips can have a variety of shapes, as can individual upper and lower lips. Study the different lip shapes created by varying this line. Pay close attention to this shape when drawing the mouth.

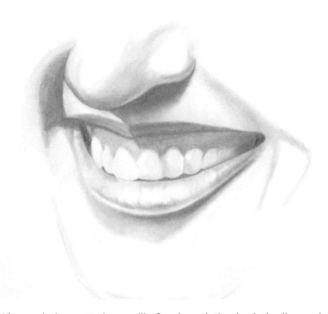

When painting portraits, you'll often be painting both the lips and the teeth. To paint realistic-looking teeth, don't separate each tooth with a strong line (creating a picket-fence appearance). Instead, shadow the teeth with a bluish tone. I personally don't put a slightly yellow layer on the teeth, although that's what many people naturally have. We want our portrait subjects to have million-dollar smiles.

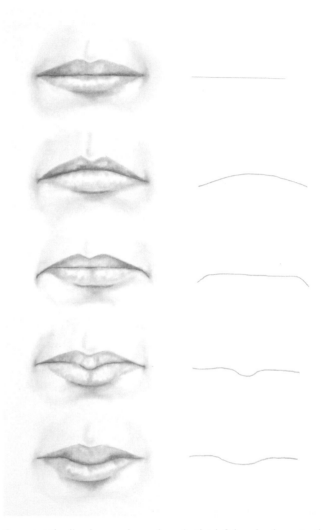

Compare the lip shapes shown here in the left-hand column to the shape of the dividing line shown in the right-hand column.

Degree of Detail

I've found that often when I say "degree of detail," I'm really addressing how many layers it takes me to get to the final painting. The more layers, often, the more contrast. Some of the examples with less detail are typically painted with looser strokes. It's a matter of personal choice.

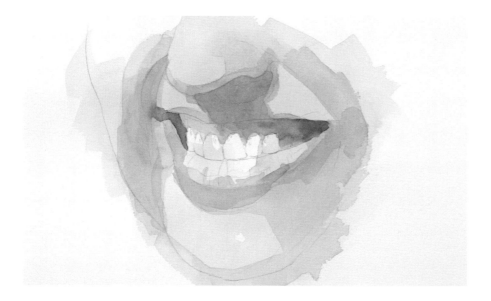

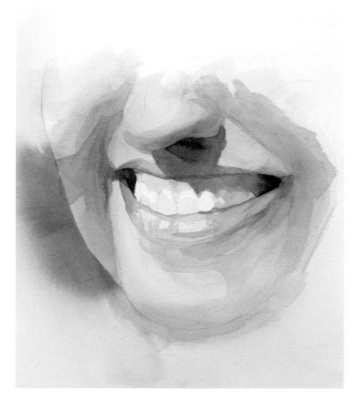

This is very workable as a finished piece. You can see many of the strokes I used, yet it still has some depth in the pigment.

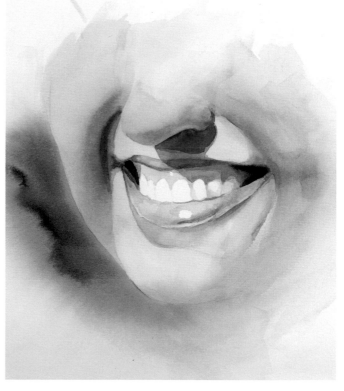

I rather like the richness of this piece. Same drawing, same base layers as the other two examples, just more layers. I also smoothed some of the strokes more.

Painting the Lips

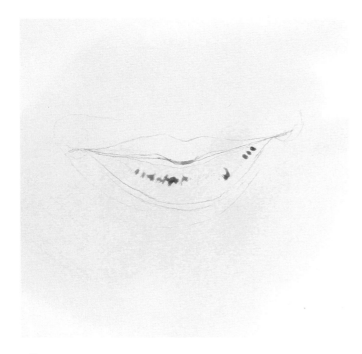

① Masking and first wash

Because these lips had very white highlights, I placed masking fluid to keep the white of the paper. Once that was dry, I wet the entire sheet of paper, dumped the excess water and did a first wash with a pinkish (Quinacridone Rose) base color.

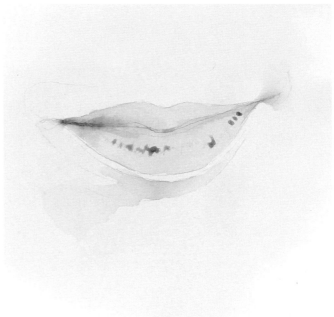

② Darken lips

I rewet just the lips and painted them the same color, but the second layer makes the lips darker. While it was still wet, I floated in purplish-pink at the corners with a mixture of Quinacridone Rose and Cerulean Blue. Once they were dry, I rewet under the lip to start the shadow and the lighter shape as well as a slight dark on the left corner.

③ Darken upper lip

For this layer I pushed the blues, using Cerulean. I didn't like the look of the upper lip at this point as it ended up too gray. I added a hint of the philtrum (the midline groove between the nose and upper lip) and redarkened the shadow under the lip.

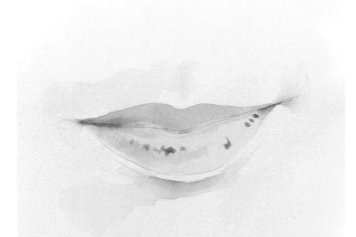

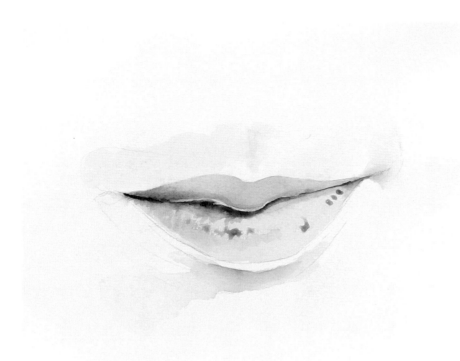

④ Shadow darks

Remember how I didn't like the rather gray color in the last step? This time I just brushed on a bit more pink to warm up the lips. I added a purplish shadow of Quinacridone Rose and Anthraquinone Blue with some Cadmium Red to keep it from getting overly pink. The shadows on the lower lip show the pattern of tiny lines or creases in the lip.

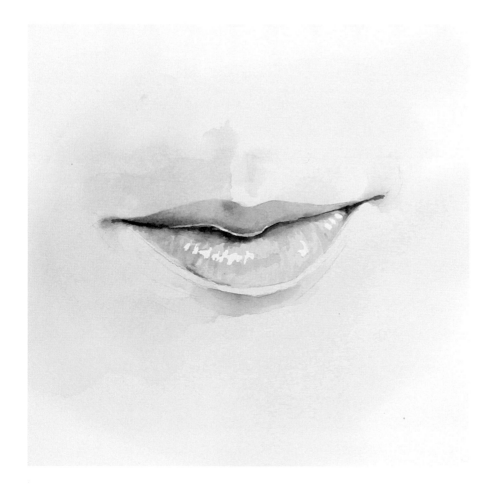

⑤ Finish

I studied the lips very carefully as the color and value changes were very slight. I felt the upper lip needed even more pink in the corner, and there was a slight roundness in the center that I wanted to show more. I darkened the corners more, allowing the color to bleed out onto the face. As the whites on the lip were sharp, I didn't soften any edges when I removed the masking.

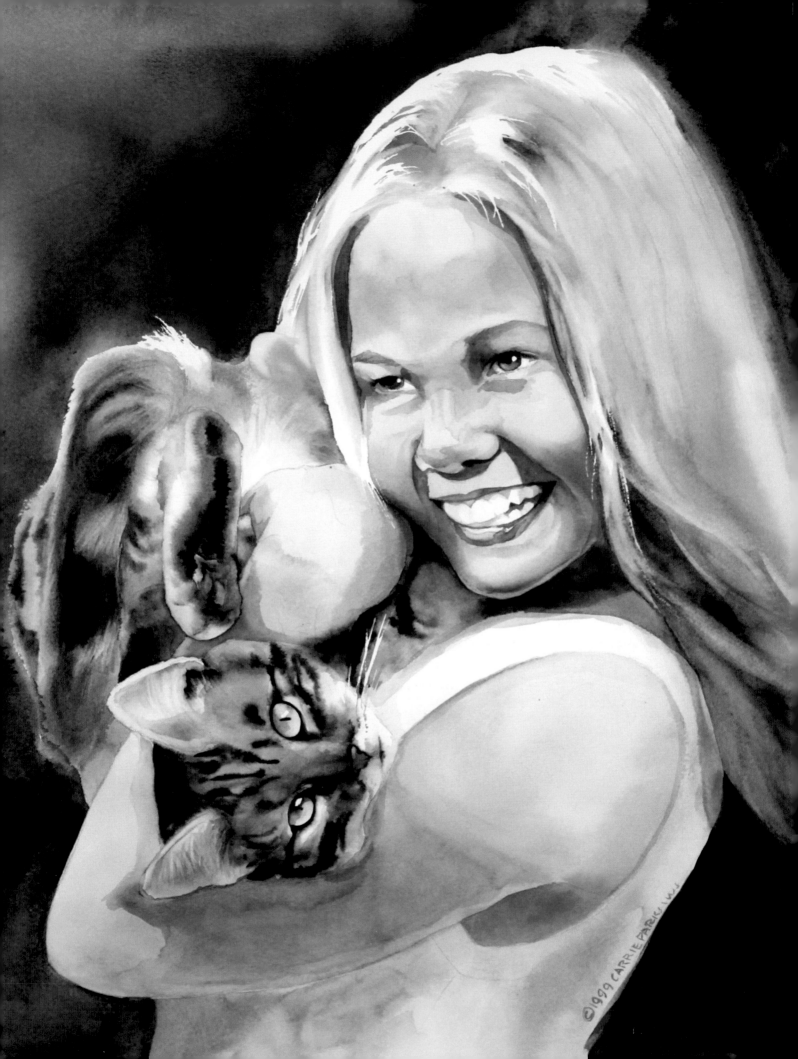
©1999 CARRIE PARKS IWS

Chapter 6

Painting Hair

There are so many different types of hair that I thought I would demonstrate some of them step by step in this chapter. As it turns out, I also stepped out everything on the face, not just the hair, so this chapter has lots of painting challenges for us to enjoy. Along the way, you'll see how I paint myself into and (hopefully) out of some corners. I'll also complete some paintings where I wish I'd done some things a bit differently. You need to understand that there are always challenges and even a watercolor ancient like me does not always produce masterpieces. I figure that's a more honest way to teach you about painting faces in watercolor. I recently opened a watercolor book that started with one painting, showed a step-by-step photo or two, then changed to another version. I don't believe that helps you because you could do everything they tell you to do and you would still not wind up with the same painting at the end. The good news is that, in this book, I'll tell you what I wished I had done and show you how I fixed the parts I didn't like. Sound like a plan?

POINT OF VIEW
30" × 22" (76cm × 56cm)
Transparent watercolor on Arches 140-lb. (300gsm) cold-pressed paper
Collection of Carolyn Jones

Painting Straight Blond Hair

This first painting presented a host of watercolor challenges: movement, light-colored hair and features somewhat distorted by the hair blowing across the face. It's a great photograph, however, of a beautiful girl. I couldn't resist the challenge.

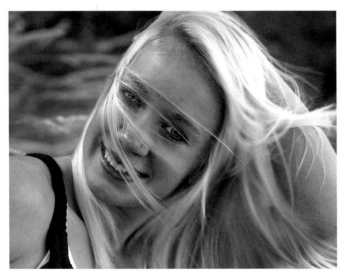

A beautiful reference photo makes for the start of a great painting. This image is courtesy of Dave and Andrea Kramer, Stampede Lake Studio/Kramer Photography. Used with permission.

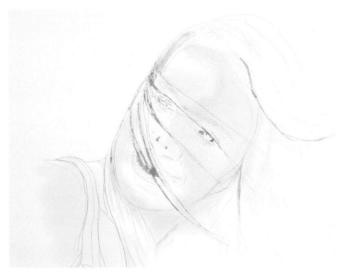

① Drawing, masking and underpainting

As always, I begin with a good pencil drawing and then mask out the lightest lights to preserve the white of the paper in some areas. I place the masking across her face, on her teeth, the whites of her eyes, a gleam on her nose, and some outside strands of hair. I use a ruling pen to apply the finer lines of masking fluid and an old cheap brush for the larger areas. Her skin tones are in the pink area, with a purplish hint on her chin. The pink is Quinacridone Rose and the purple is Quinacridone Rose with Cerulean Blue. I wet the paper, dump off the excess water, and flow on the underpainting color. I do have to be a bit careful as I don't want a lot of pink in her hair.

❷ Start building tones without dribbling

I don't mean to suggest that I am actually dribbling . . . well, I don't think I am. I'm building her skin tones with a second layer of Quinacridone Rose, but unlike my paintings of darker-haired subjects, I'm being careful to keep the pink color from getting too pink in her hair. That's one of the challenges of painting blondes.

❸ Seek out shadows

Once again, you'll see that I'm being careful to keep the pigment out of her hair. To do this, I apply the color where I want it, then take a second brush with just clean water in it and soften some of the edges. Where I want a sharp edge (such as under her lip), I'll not soften the edge but instead allow the dry paper to keep a sharp edge.

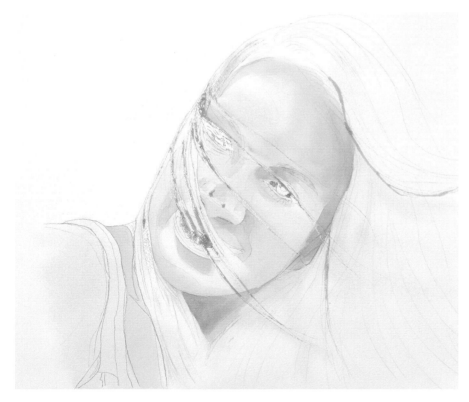

❹ Keep building

I don't know how many times I can say this, but please keep in mind that it's always better to gradually build up your darks than to try to lighten something you've made too dark. Here I'm still using Quinacridone Rose with a bit of Cadmium Red Light.

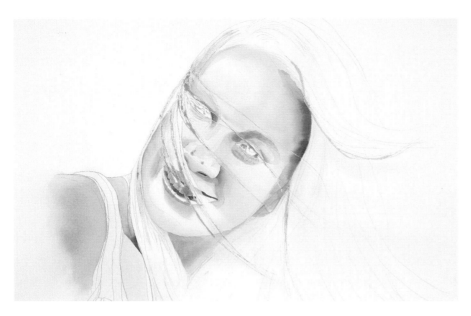

⑤ Change colors

Now I'm a little sick of pink. I'm still building the darks very carefully, but this layer has some variation in it: Quinacridone Rust and Maroon Perylene mixed with lots of water. The rough edge at her hairline won't be a problem as that's a darker area anyway.

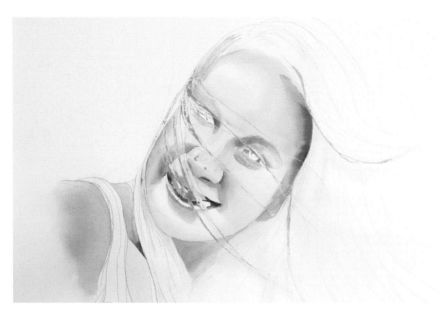

⑥ Create contrast

Not a big step forward here. (I guess I'm making up for all those times I leaped ahead without stopping to photograph my progress!) At this point I need a pretty good dark to let me know where I am, so I paint the corners of her mouth.

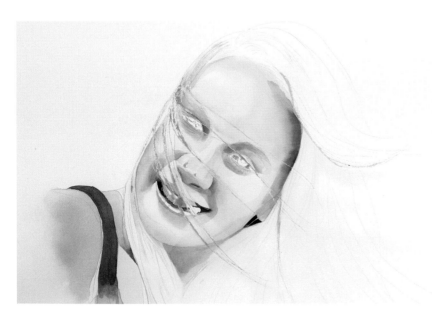

⑦ Clothing and still more darks

I just mentioned I was sick of pink, so I paint her shirt . . . magenta. I continue adding layers of pigment using Quinacridone Rose mixed with Cerulean Blue, Cadmium Red Light, Quinacridone Rust and even Terra Rosa.

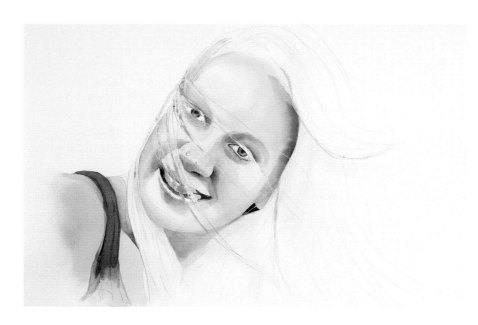

⑧ The eyes

At this point, because of the masking on her hair and parts of her eyes, things get a little tricky. It's pretty much impossible to pull up one section of masking without pulling up all of it in that general area. To work on the eyes, I remove the masking from the surrounding hair as well. That can be a problem if I'm not careful in subsequent layers.

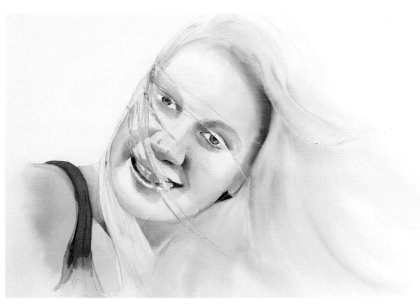

⑨ Hair

Finally! We're getting to the hair. I'm using a very pale wash of Burnt Umber (and I do mean *pale*) with a little bit of Turquoise for variety. I add a smidge of very diluted Anthraquinone Blue to the Burnt Umber to slightly gray it. I wet the hair while my paper is lying flat, making sure I wet almost the entire paper except the face, dump the excess water, then apply the color while the board under my paper is tilted. The strokes (the fewer the better) of color duplicate the direction the hair is flying.

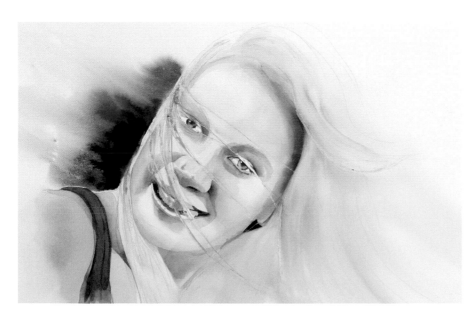

⑩ Background

This seemed like a good idea at the time. I don't know, maybe her bright blue eyes influenced me. I want to have a strong dark next to her face. I mix Anthraquinone Blue with some other blue I found on my palette. Bad idea. I hate it. Not to worry though. I can fix it in the next layer.

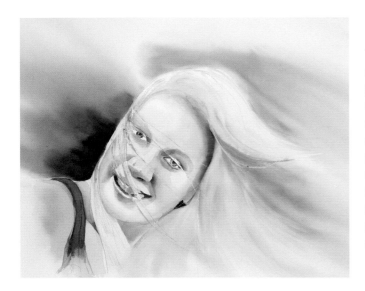

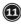 **More background, fix problems**

The background blue from the last step just isn't organic enough. In fact, it stinks. I rewet the blue area and add some yellow-greens. Most any transparent yellow might work, depending on how bright you want the Green to end up. I really don't like most tube greens. Olive Green might be the exception. I can get most greens more toward olive by adding an orange shade (such as Quinacridone Rust. Yep, love that color!). I do the background in two steps: tilting the board to the upper left for the darks next to her face and to the lower right to paint the background above her head. You can easily see a space above her right forehead where those two steps don't touch.

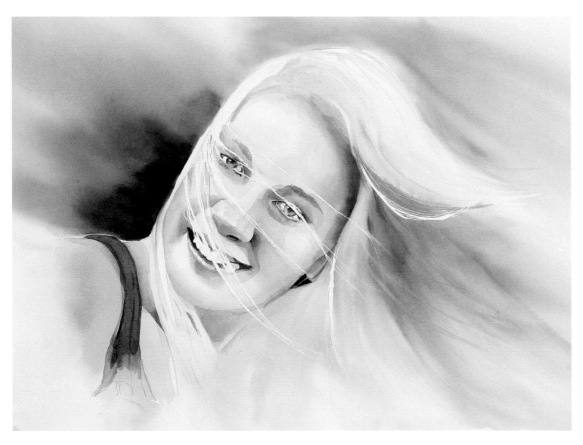

⑫ Finish

I finish the eyes, touch up the teeth and darken the hair under the flying upper part. The colors are the same: diluted Burnt Umber with a bit of blue. While the paper is still wet, I take a 1-inch (25mm) flat brush and lift a few strokes through the darker area. I also start doing some negative space painting in the hair and on the neck, but that can get addictive and lead to noodling, so I stop. I think her face is too chalky and start to place a warm wash of Quinacridone Rust over the left side of her face, but it soon becomes apparent that to do a really good job, I need to remask the white hairs across her face. I decide to leave it as is and just tell you what I'm not happy about. Kind of a "Do as I say, not as I do" approach.

Painting Dark Curly Hair

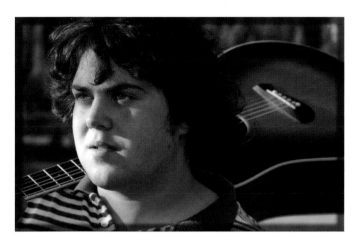

I've painted curly hair elsewhere in this book, but I really liked the sunlight on this fellow's face as well as his curly mop. This excellent photograph is courtesy of Dave and Andrea Kramer, Stampede Lake Studio/Kramer Photography and used with permission.

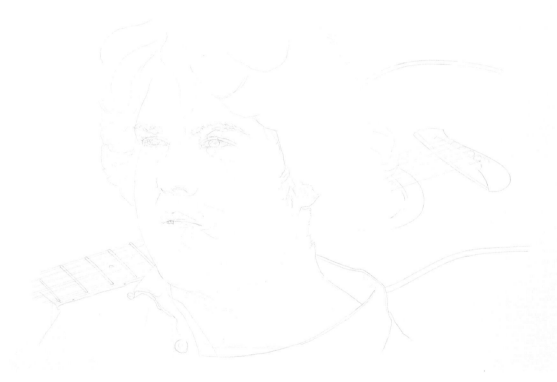

Once again, Rick does an outstanding job of drawing this image. The top of the young man's head is cropped, so even though I'm using almost a full sheet of watercolor paper, I'll crop the final image.

Tip

Don't make up something if you don't see it on the photo. Don't see the top of the head? Crop your painting.

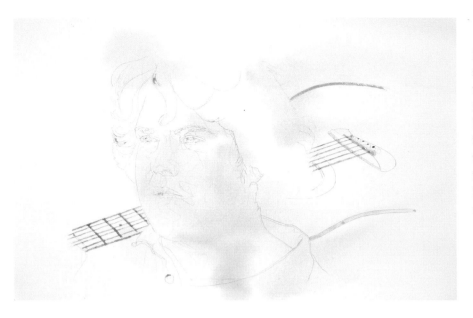

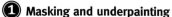 **Masking and underpainting**

I masked out the curls in his hair, the strings and other parts of the guitar, as well as highlights on his face. After the masking dried, I painted an underpainting. I may or may not end up using these colors in a later step—I just need to be sure that I don't place complementary colors in the layers (such as a yellow layer then a lavender layer) unless I really do want mud.

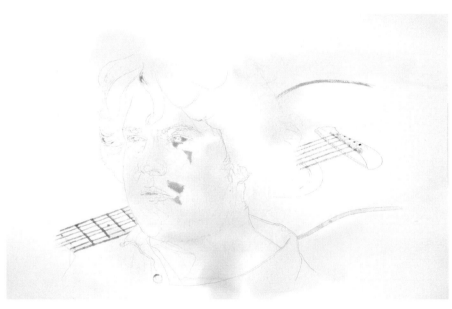

② More masking

The real advantage of Pebeo Drawing Gum over other masking fluids is that you can apply it over color, and it won't tear up the surface or lift most colors. Here I decided to preserve the underpainting in a couple of places, allowing me to paint much looser and not have to worry about painting around those spots.

③ Rewet and create edges

If you need a softer edge, like the one going down his face, you can rewet the entire sheet of paper with a spray bottle. If your earlier layer is dry, you won't disturb it. Use a round brush to apply the layers as it's not as likely to lift pigment. In this case, I kept the paper dry but softened a few edges with a second wet brush. This is a combination of Quinacridone Rust and Cadmium Red Light.

④ Get contrast

Using Quinacridone Rust almost straight out of the tube, I dropped in some dark areas. Even if I painted over this area, it wouldn't hurt anything, and the darkness gave me a guide as to where I was.

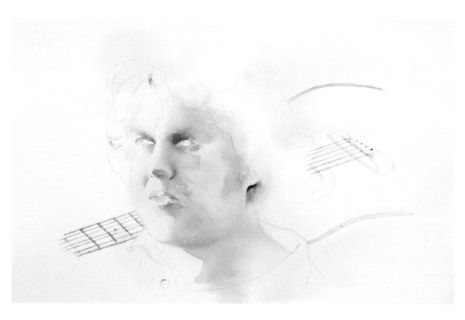

⑤ Shift color

I did a couple of things in this piece that I didn't really like. This step is one of them. I wanted to get away from the too-orange appearance, so I painted a layer of diluted Burnt Umber. It just made his face look dirty. I should have used more of a Cadmium Red or one of the other red tones.

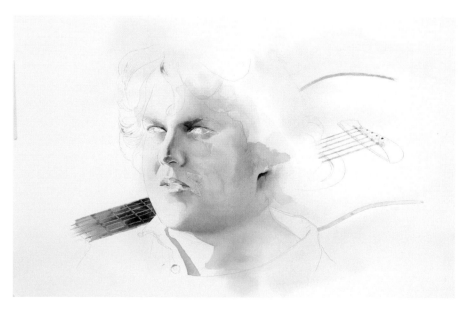

⑥ Repeat dumb step

I just told you how I didn't like the diluted Burnt Umber, then I once again applied it. You'd think I would have learned. Now I have more dirt on his face. I did like the darkness of the Quinacridone Rust going down his nose. I also painted the fretboard a brownish green made of Burnt Umber and Olive Green.

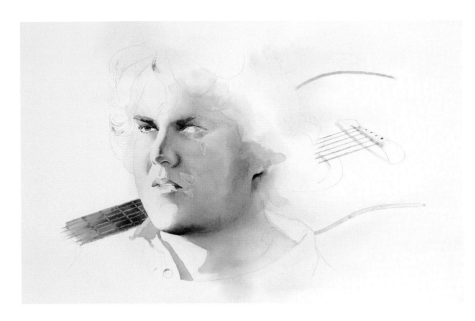

7 Paint an eye, darken shadow

I ran a wash of Cadmium Red Light and Quinacridone Rust over the entire face to try and kill that Burnt Umber tone. I then really darkened under his chin. I decided to start on some detail by painting his right eye. I paint these details by just looking at the photo and duplicating what I see. He has greenish eyes, which I created by mixing blue and yellow, not tube green. Which blue and yellow? Depends on the shade of green you're seeking. Okay. I'll tell you: Cobalt Blue and Azo Yellow.

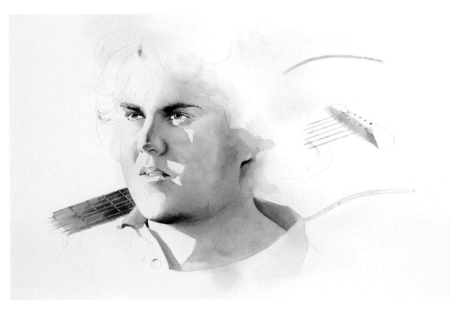

8 More detail

I pulled the Pebeo masking off his face and painted the other eye. I put Olive Green (apparently my favorite color this year along with Quinacridone Rust) in his collar.

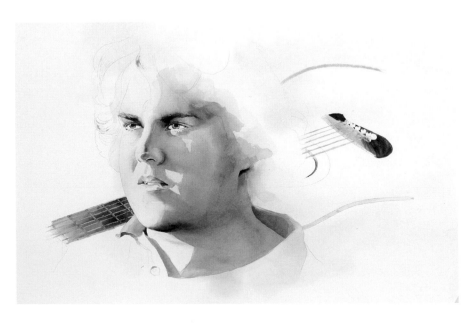

9 Redarken shadow side

I had two reasons to redarken the left side of his face: I still hated the Burnt Umber and I was getting really dark on the hair, so I didn't want his face to suddenly turn pale in comparison. I used a wash of Quinacridone Rust and Cadmium Red. I also painted some detail on the guitar.

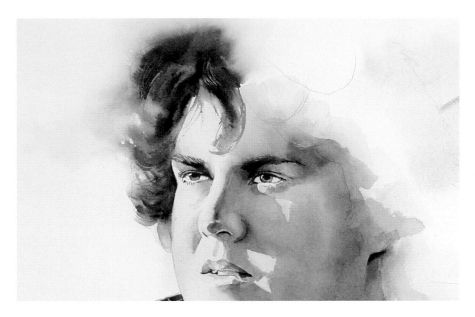

🔟 Start hair

I painted the hair in two steps. I placed fresh paint on my palette: Anthraquinone Blue, Burnt Umber, Quinacridone Rust and Transparent Orange Iron Oxide. I wet the hair area carefully next to the face, but used a spray bottle to wet toward the top of his head to get the pigment to run. I dipped my brush into several colors at the same time. My strokes mimicked the curl of the hair.

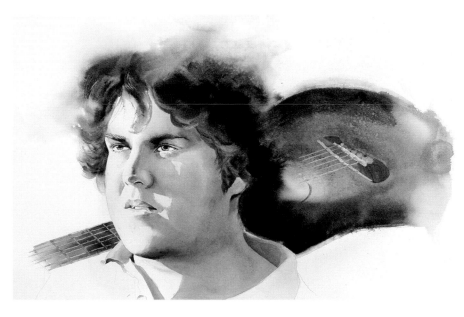

⓫ More hair

Here's another case where you should do what I say, not what I do. I thought I'd paint the hair and guitar at the same time as they were connected. Bad idea. I should have just worked on the guitar, then done the hair as another step. It was just too hard to keep everything wet, create curls, paint the guitar and not have it blend the way I wanted. So, here's what I should've done: wet the next section of hair and the guitar body, then paint Anthraquinone Blue, Burnt Umber, Quinacridone Rust and Transparent Orange Iron Oxide using a wavy brushstroke.

⓬ Finish

This painting gave me fits at times. I was careless in removing the masking from the guitar strings and smeared a dark blob. I cleaned it up, but it was irritating to get to the last steps and then do such a careless thing. I added shadows to the fretboard and on his forehead, painted the sound hole and suggested the body of the guitar. Done.

Painting a Shaved Head

I know, I know, this is a chapter on hair and here I am painting a shaved head. It's a great thing to master, as painting some babies presents many of the same challenges. Not to mention shaved heads are quite popular now. The photo of this handsome fellow is another from Dave and Andrea Kramer, Stampede Lake Studio/Kramer Photography, and used with permission.

As always, I'll start with a detailed drawing. It's helpful to sketch where some of the major shadows are on the shaved head.

❶ Apply masking

I'm going to get dark on this piece, so using the Pebeo masking will keep the highlights for me, and I can be looser in my paint application.

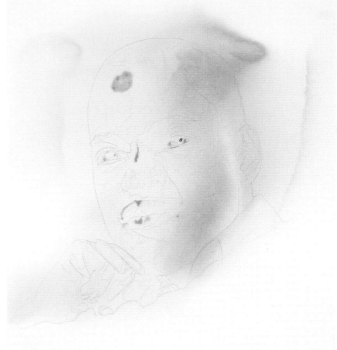

❷ Underpainting

I don't know why I didn't introduce some different colors into the underpainting. I think I was fussing about the boldness in the colors. In retrospect, I would have added a blue, teal, something interesting. The colors I used here were a mixture of Burnt Umber, Quinacridone Rust and Transparent Red Iron Oxide. I lifted a lighter area up his jawline next to his left ear for the reflection from his white shirt.

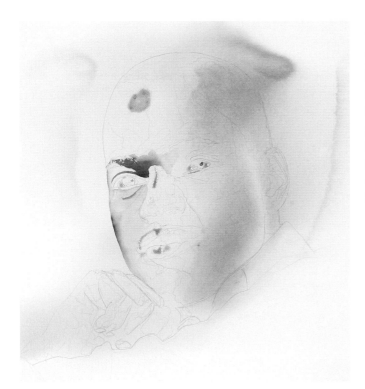

❸ Start on shadows

I don't know if you've asked me this yet, but I know you're thinking it: Where do I usually begin with the layering? Good question. The answer: all over. What's interesting is that I finish drawing the eyes first but paint the eyes almost last. I paint from large details (overall skin, shadows) to small details (eyes). I'll work from light to dark. In this case, I've added some dark shadows, knowing that they'll not be nearly dark enough when I get further along. The darks in this case are Quinacridone Rust and Transparent Red Iron Oxide.

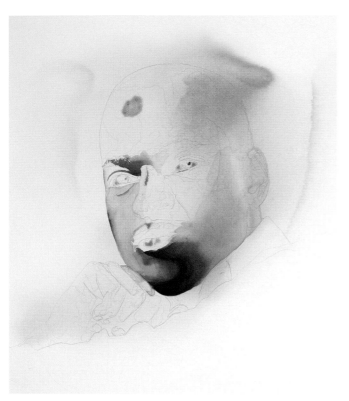

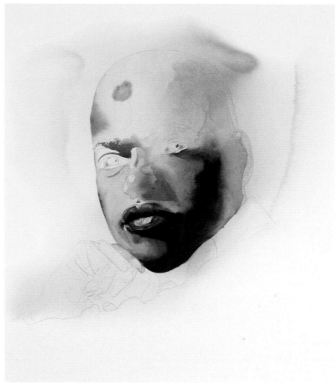

④ An "eek!" moment

This is why you don't paint your friends, or at least don't show them their portraits in progress. I knew I had to get really dark, so I dove in and mixed Burnt Umber with Anthraquinone Blue to create the really dark color. Once you get dark like this, it's an act of faith to continue, believe me.

⑤ Keep going

In this step, I rewet the left side of his face and continued with the same dark, leaving the right side of his face lighter. I would probably need to darken the cheek there a bit more later on. I also worked on the lips, using Cadmium Red and Maroon Perylene.

⑥ Paint nose, start hand

Now that I had a major area of darkness, I went back and repainted the shadows around the eyes. I used the same colors, but to get the darkness, I used fresh pigment and very little water. I painted on dry paper. I didn't stop and fix up or smooth out areas at this point—I want to see the whole picture.

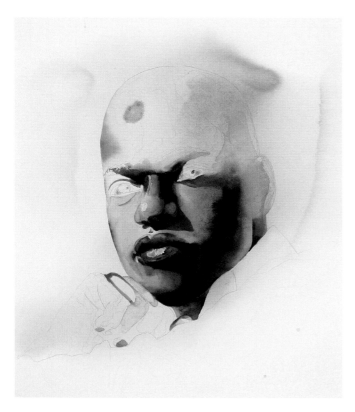

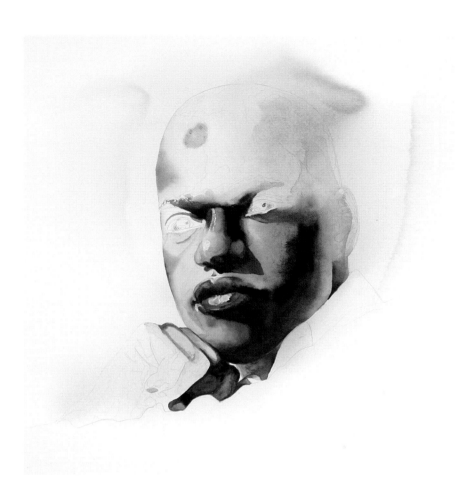

7 Continue hand

There's nothing tricky about painting hands; where you see a dark line, paint a dark line. Where you see a black shape, paint a black shape. The reference photo has all the information; just focus on each part. If it ends up looking too choppy, when you're done apply a toned wash over the hand to pull it together.

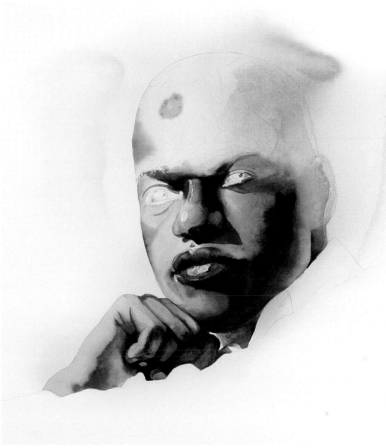

8 Finish hand

I wanted a warm glow on the hand, so I wet that portion and placed a line of pure Quinacridone Rust in that area. I had very little water in my brush as I didn't want this to bleed very far—just enough to soften the edges. Once all the details were painted, I applied a single wash over the entire hand to pull the elements together.

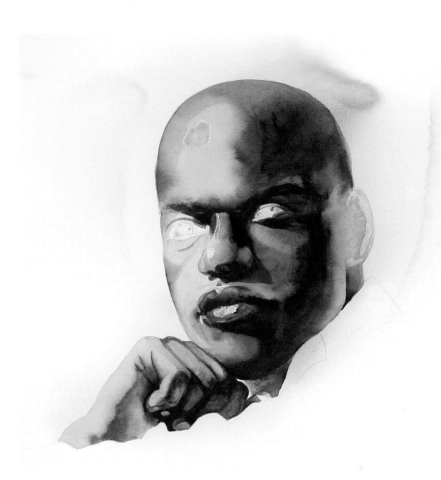

9 Top of head

I rewet the entire top of his head and worked downward onto his forehead, using the same combination of colors, Burnt Umber and Anthraquinone Blue. (If you're not using M. Graham's Anthraquinone Blue, you could use Holbeins' Royal Blue.) I added a wash of Quinacridone Rust to his left cheek and above his left eye to darken it and warm it up.

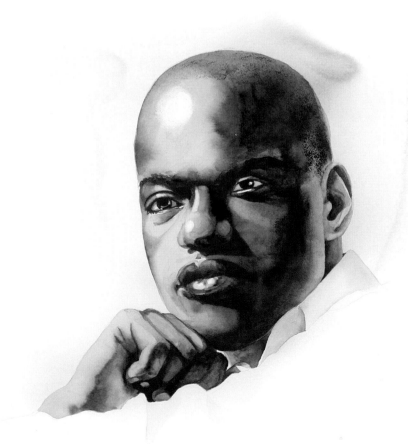

10 Finish eyes, paint ear

When the top of his head was the correct value, I dabbed it with a natural sponge. I wet it, then squeezed it as dry as I could get it, dipped it into the darks on my palette and dabbed the color sparingly on his head. Then I finished the eyes, removed the masking and used a Fritch scrubber to soften the edges around the white where I had placed the masking. I added a small shadow around the collar using Cerulean Blue. I painted the ear the same as the hand: if it's a dark shape, paint a dark in the same shape. I didn't think to myself, *I'm painting an ear. Let's see, what does an ear look like?* Instead, I thought, *Skinny dark line, oval light area.* With the features done, I set the painting aside. It wasn't quite what I wanted, but I needed to get away from the painting to see what I needed to change.

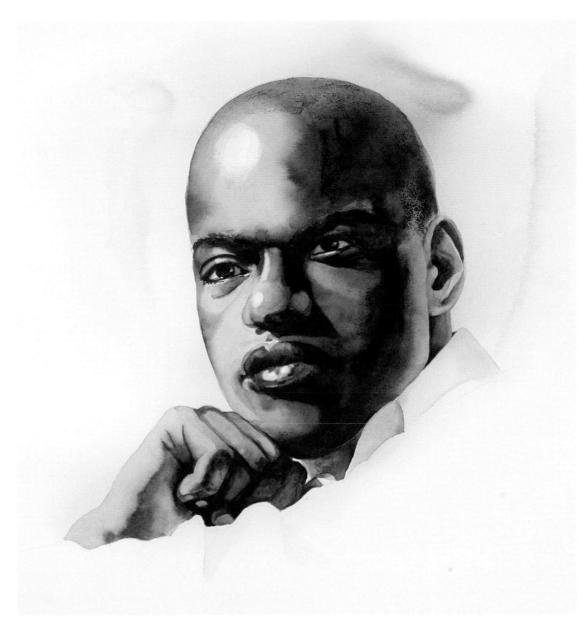

11 Fix left eye

The problem was his left eye: it looked too squinty, the white was too pronounced and the highlight too bright. Using a Fritch scrubber, I scrubbed out some of the pigment on the eyelid and opened up his eye.

Painting Hair in Profile

This photograph had such wonderful lighting and was in profile, which I hadn't done before in this book. I also thought the challenge of his hair blending into the shadow on the tree to be unique. This is another excellent photograph by Dave and Andrea Kramer, Stampede Lake Studio/Kramer Photography, and used with permission.

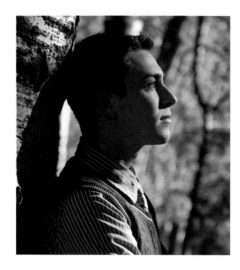

Rick did this detailed drawing. Actually Rick gives me far more information in his drawings than I'll ever need. I'd never tell him that, of course, because I'm too lazy to do my own sketches.

Tip

Want to know a nifty way to remove Pebeo Drawing Gum? Press a piece of drafting tape onto the dried masking and pull up.

❶ Masking and underpainting

After applying masking fluid to selected areas and allowing it to dry, I wet the entire paper, dumped the excess water (in case you're wondering about wetting the paper—I have so much water on my paper that it forms puddles) and applied a pale wash of Quinacridone Rose mixed with Quinacridone Rust for the underpainting.

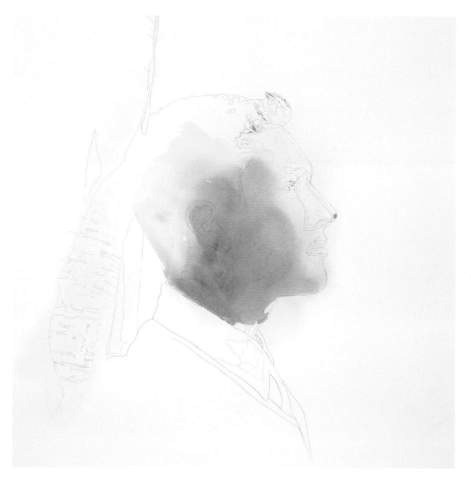

❷ First layer

Here's where I made a mistake and you'll make a bigger one if you don't read this first. I used that silly Burnt Umber on his neck and I hate it. That's okay, as I can fix it in another layer. Because the young man had red-blue skin tones, I used Maroon Perylene. Now here's a caution: M. Graham paints (the ones I prefer) are extremely pigmented. And Maroon Perylene is a staining color. You'll want to be sure the pigment is thinned quite a bit (use a scrap piece of paper to test) and make sure you put it only where you want it. The entire face is wet in order to have that glowing edge.

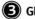 Glazing

In this step I selected a few places where I wanted to build up the darks: the nose, eye, upper lip, under the lower lip, and the ear. The layer is a very diluted Maroon Perylene. If you're not sure you want to tackle a staining color like Maroon Perylene, you can mix a purplish-red from a blue and a red.

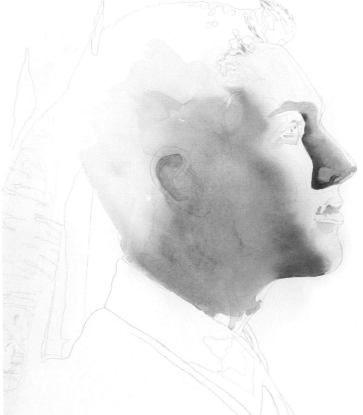

④ Get bold

Well, I'm not being as bold here as I was in the previous demonstration painting, but I really did layer on some heavier pigment in this step. I mixed Quinacridone Rust with the Maroon Perylene and redarkened the point where his face starts in shadow. Be sure you wet the paper well beyond where you want the pigment to go so you don't end up with a weird line. I placed a second, darker layer where the nose casts a shadow onto the face.

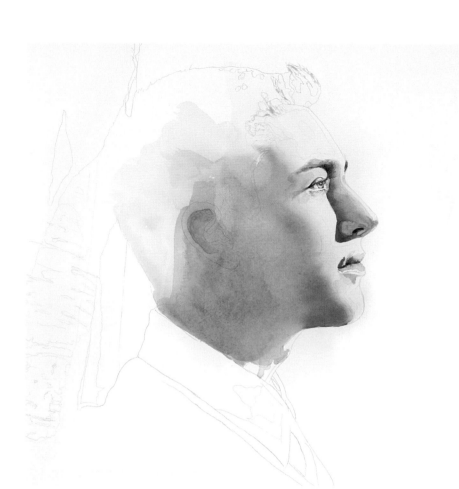

⑤ Eye details

Just because I could, I decided to finish the eye. Eyes in profile are very small, and as there was nothing around his eye that I could smear with water or pigment, I thought you might enjoy at least one painting where the subjects didn't look like eyeless zombies until the last step. The glow to the lower part of the iris was created by painting in the color, then lifting it back out with a damp, small flat brush.

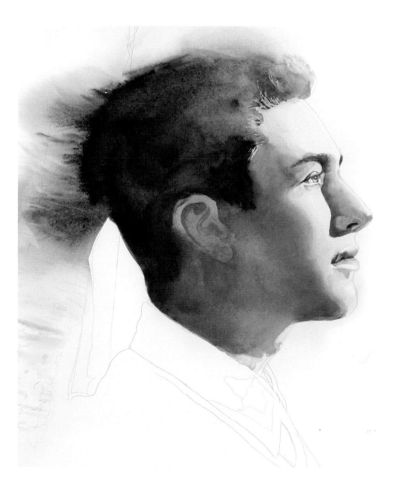

⑥ Reapply wash and start hair

I didn't do this all in one step. First I wanted to pull the face together and get it slightly darker. I created a puddle of color, mostly Quinacridone Rust as it is very transparent. Then using a large round brush, I glazed a layer over his face, keeping away from the lighter areas. Caution: Don't add extra water (or have water in your brush) when you dip into the color. Your brush should be wiped dry. One, I repeat, one stroke is best. Once I did this, the Burnt Umber settled down and no longer really bothered me. Next I wet the entire hair and tree trunk area plus sprayed a bit onto the top, then painted the hair with a thick mix of Anthraquinone Blue and Burnt Umber (I'm willing to forgive the Burnt Umber in this case as it made for nice hair). While the paint was still wet, I implied the texture of the bark with a round brush.

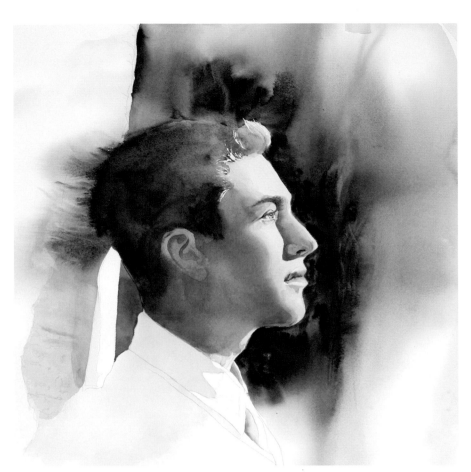

7 Clothing and background

I removed the masking at the front of his hair, then painted a shadow on his shirt, dried it, then began working on the large background area behind him. The intense background makes his face even more interesting. I used Olive Green, Anthraquinone Blue, Quinacridone Rust and whatever other dark, earth-toned colors I had on my palette. First I wet the background (really wet), dumped off the excess water and painted with my paper lying flat at first, then with it tilted for a more vertical run of pigment. I painted the small background area between his shirt and the tree after everything else dried.

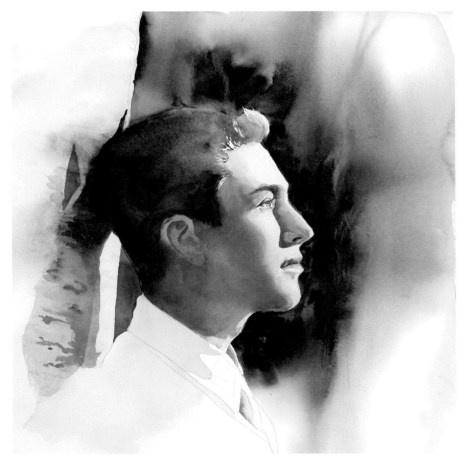

8 Remove the hair-sucking tree shadow

Yeah, it looked like that to me, too. To fix that, I darkened the back of his head so it looked more like a shadow and had more separation from the tree. After adding a few more tree details such as the bark lines, I left the painting overnight to see if anything about it bugged me the next day.

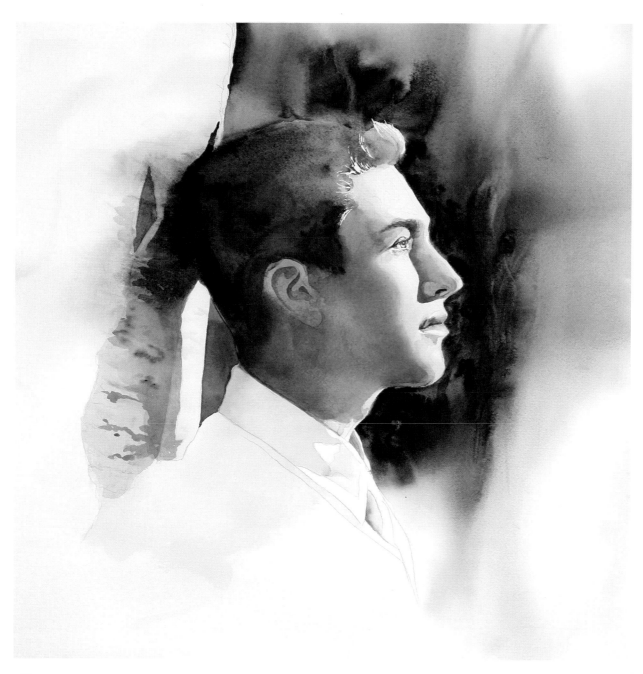

⑨ Finish

I decided I liked it at this point without doing much more than adding a bit of blue to the back of his collar. I debated on adding the navy vest shown in the reference photo, but that would mean more darks and his face would be a light area in the middle of a bunch of darks and would look like a bull's-eye.

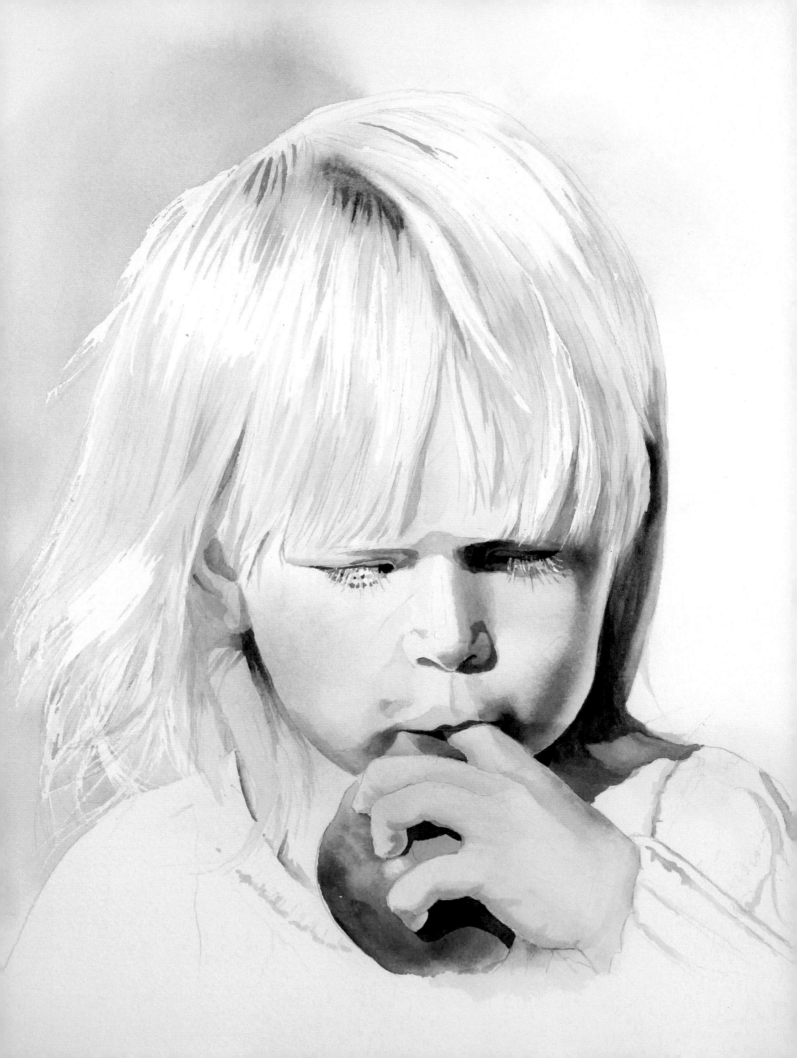

Chapter 7

Common Mistakes

I think of this chapter as "Payton's Problem Portrait"! I'll start right out by telling you that there's nothing wrong with Payton. She's a delightful child, my grandniece, and a very grand niece at that! I want to keep peace in my family, not to mention that her mother will probably be the one to choose my nursing home one day, and I want to stay on her good side.

I assigned, or more accurately, challenged the students in one of my watercolor classes to paint a portrait of Payton, then left them alone to struggle with how to do it. They'd wander over and watch me, but I gave very little one-on-one instruction or feedback. I wanted them to face the same challenges you might face in working on your own. It's hard for me to think about all the possible disasters inherent in this medium because I've been painting so very long. (You don't have to nod your head quite so vigorously at that comment)

So let's take a look at how the students did with their paintings and what we can learn from them.

PAYTON
24" × 18" (61cm × 46cm)
Transparent watercolor on Arches 140-lb. (300gsm) cold-pressed paper

Student Paintings of Payton

Payton's Peculiar Perplexity

First I provided each student with a clear photograph of the girl. I also set up the opaque projector so they didn't have to master the drawing, only focus on the painting. Was this a good idea? Not particularly. Not having drawn the image before trying to paint it meant that the students were at the mercy of seeing and accurately sketching from a projected photo. Each one was working from a different

angle in a darkened room and couldn't spend quality time figuring out what this shape or that shadow meant. The projector could shift, or they could forget to draw enough from the original to know where something needed to be, like the location of the mouth, for example. Lesson learned: Even a loose preliminary drawing helps you figure out your approach to a painting before you lay brush to paper.

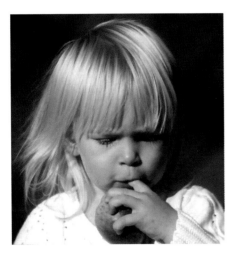

Original photograph of Payton

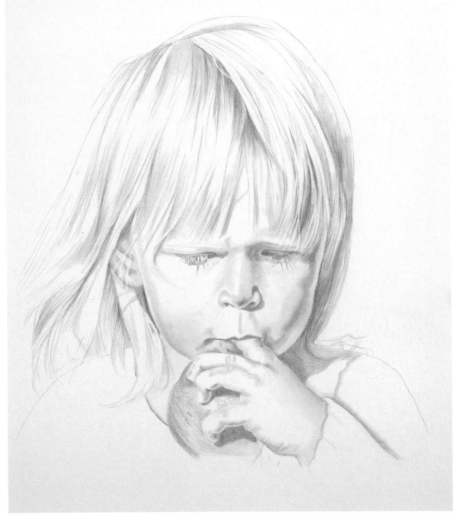

Here is my drawing based on the photograph. I took the time to really study the shapes, values and proportions of her face.

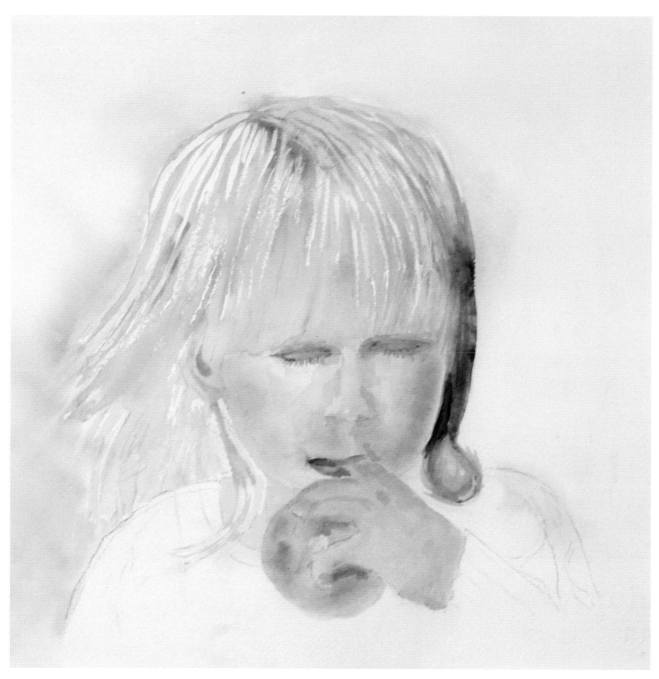

Drawing basics
Even though the original photograph might be projected for accuracy, it doesn't mean you'll be able to trace it precisely. The mouth shape is off on this student's painting. Your watercolor portraits will be greatly improved if your underlying drawing is correct.

A Variety of Challenges

A couple of things happened in this piece. First there's that big glop of green paint in the hair. All is not lost. That's an interesting color and placement. Wait a bit and when the painting is further along, come back to it. Often in our efforts to fix a problem right away, we lose sight of the whole of the painting.

A second challenge is in the values. The apple, lips and nostrils are very dark, jumping off the page. Some of the other areas of darkness on the photograph are pale on the painting. When you start your art, you have a white sheet of paper, so even middle values will look too dark.

Challenge yourself: place a dark on your painting and work your values until the dark is correct. See? The apple, lips and nostrils aren't, in fact, too dark in this piece—the rest of the work is actually too light. Once you've developed the overall work, you can always lift out color if it's still too dark.

A final challenge is where the student pushed too hard with a pigment-loaded brush, causing the reddish rough patch on the back of Payton's hand. That's something you've just gotta live with.

There are some other hiccups in this piece that are also found in others, so let's move on.

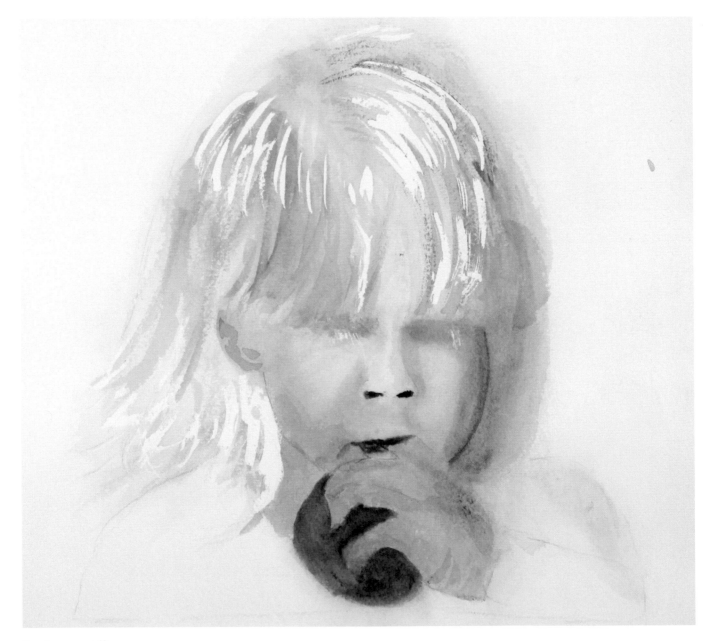

Scaring yourself
As we develop our painting, we may do things that scare the daylights out of us. Calm down, take a sip of water, and let's work on this.

Use Masking Properly

This student used Pebeo Drawing Gum to save some of the lightest areas of the face. That's fine, but some of these areas will need to be softened. The forehead and bangs are merged, and separating them is a simple fix by add-

ing the shadows caused by hair. I would be inclined to lift some of the hair where it's dark so it has more of a hairlike appearance. Overall, this painting just needs more layers to develop it and close attention to subtle shading.

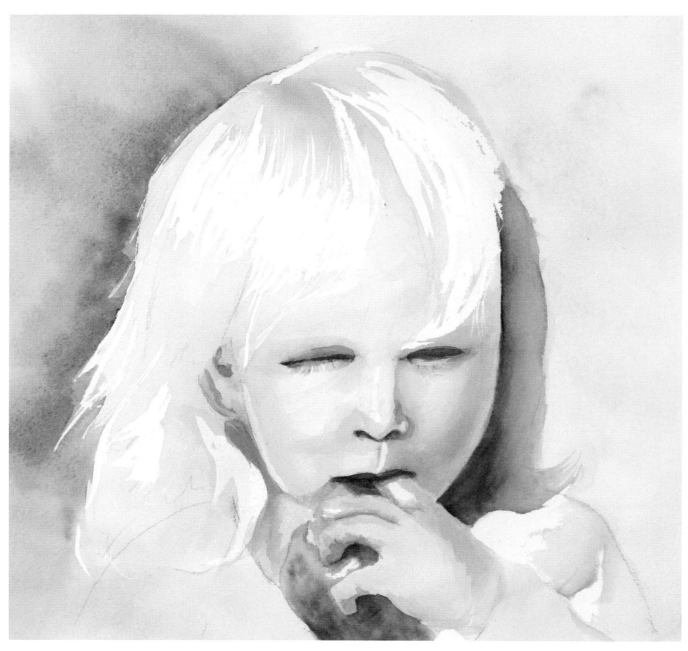

A good start
With a bit of softening and a few more layers, this is on its way to a nice piece.

Tip
I have both a Fritch scrubber brush and a level lifter for softening edges. Using the right tools makes everything so much easier!

Fix Drawing Errors

I like the color choices and the interesting brushstrokes in this student's work. Here's where the experience of drawing the piece first would have made a huge difference. The right nostril, fingers and ear all had drawing errors, which translates into painting problems later. Fixable? Yes, lifting out some areas with a medium-soft brush and changing some shadows will help. The mouth is a slightly different shape from the photo, but it's not distorted. If you're not trying for an absolute likeness, it isn't critical that you remain absolutely faithful to the reference photo.

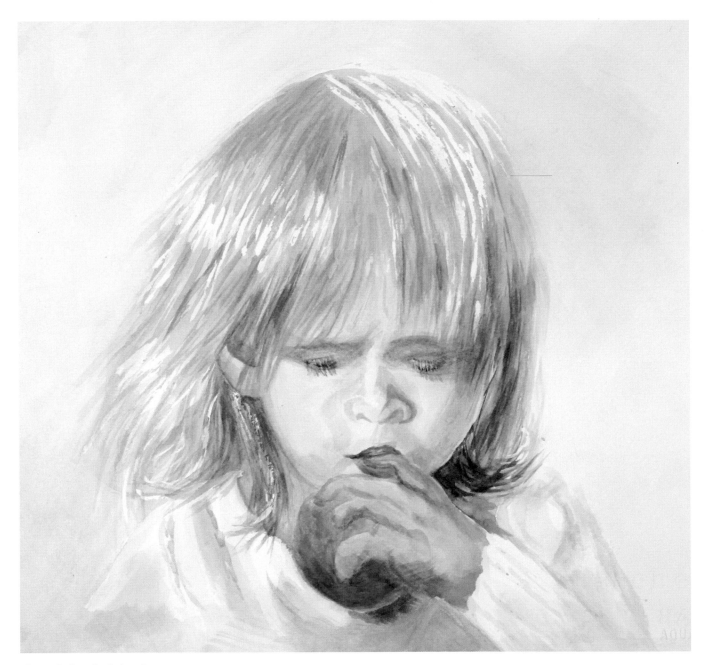

Nice painting, bad drawing
There are some nice elements in the brushstrokes and color, but the drawing wasn't sound.

More Masking Problems

I suspect this student was in a hurry to finish the project or move on to one she really wanted to do. She applied the initial masking fluid in Payton's tresses with too large of a brush, causing it to look like white eels rather than hair. The strokes also didn't go in the direction of the hair's growth, so her head looks flat on that side. Take care in your application of any masking fluid as it will slow you down later when you need to correct it. Fixing it would involve scrubbing some of the whites to merge them, then repainting the golden locks.

The shadow in the hair on the right side got too dark too fast. Take your time. The paper will wait for you. Be wary of going wild with an itty-bitty brush when applying eyelashes. A few lash lines go a long way.

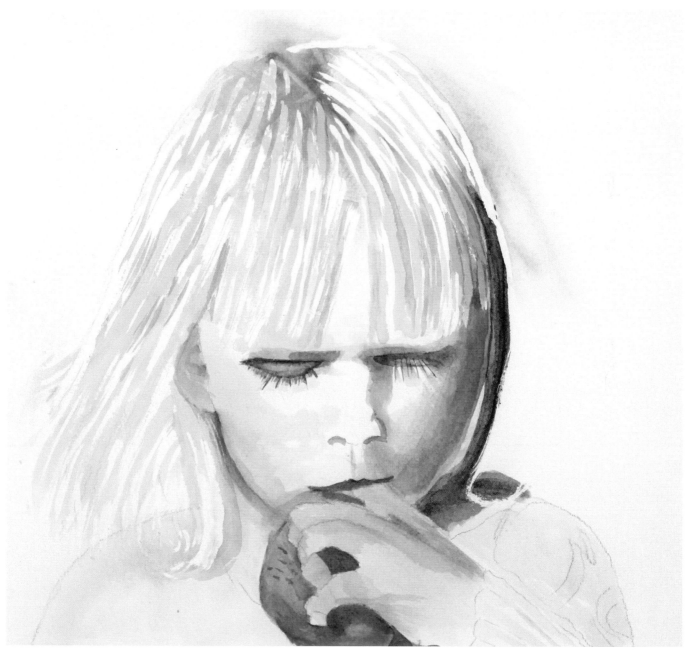

Zipping ahead
Wild thing! Going too fast on a painting will slow you down in the end.

Too Small Paintings

Although you won't be able to tell by the photo below, this painting is smaller than the rest of the class's work. Students just make their art that much harder when they work that much smaller. First of all, the masking in the hair has to be, well, hair-fine. You should probably not even use a brush; instead, use a ruling pen. A brush is twice as difficult because you have to control twice as much flow of color across the face. The amount of mastery of water and pigment required on this small work so frustrated the artist that she took opaque paint and painted out some of the color. That opaque paint becomes a further problem as it sits on the surface of the paper waiting . . . just waiting . . . like a hungry coyote eyeing a chicken coop—for her to add more pigment, at which time it will pounce on her color and turn it into a muddy blob. I understand she has since gone into counseling and has sworn off opaque color.

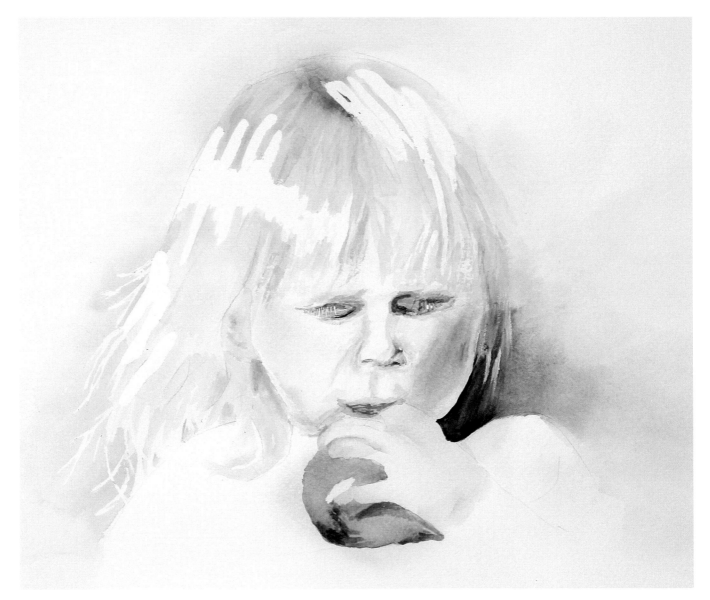

Size matters
The problems you might face in doing a watercolor portrait are exponentially increased when you paint small.

Choose the Right Pencil

I've touched on a lot of mishaps that face the student artist. Here we face yet another one. Wrong pencil. The student here used a slightly dull 6B lead. The pencil lines are like the outline you'd find on certain illustrations, not the painterly image she desired. Be sure you check which pencil you've picked up before drawing with it. Starting with an HB pencil would have made all the difference. This student could have taken a kneaded eraser and lifted or gently erased the lines before applying the paint.

I notice she started to paint a teal background on the left, but left a hard edge. I like the color, but she needs to soften that edge with water; otherwise I keep looking at it and wondering what it is supposed to be.

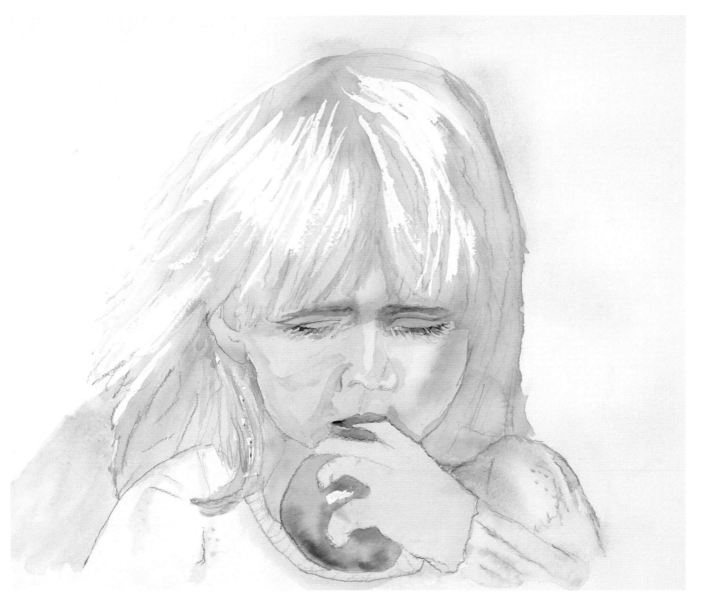

Back to basics
Your art starts before you pick up a pencil.

Tip
Think through the steps somewhat before picking up your brush. Plan a little. Think ahead.

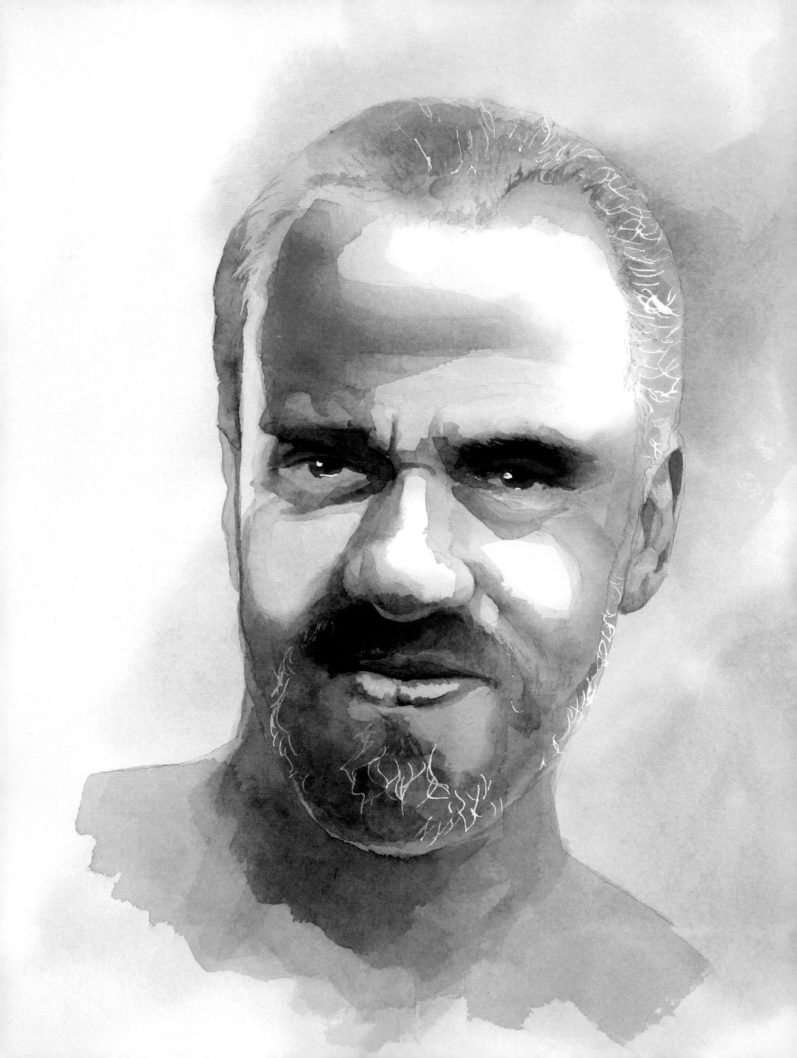

Chapter 8

Stepping Out of Your Comfort Zone

Watercolors may already be pushing your comfort zone, so since you're already hanging in there by a thread, let's push some more. This is the chapter where you get to mess around, challenge yourself and maybe find yet another way to express your artistic side.

In earlier chapters we've gone into drawing and painting primarily from photographic sources. We're going to look now at drawing and painting from life and working with other types of surfaces besides watercolor paper. I'd recommend trying these techniques one at a time as opposed to, for example, trying a life painting on gessoed watercolor canvas. Your cries of anguish might upset the models

J. B. LINDSEY
22" × 15" (56cm × 38cm)
Transparent watercolor on Arches 140-lb. (300gsm) cold-pressed paper

Life Drawing

There's something to be said for painting directly from a model. What that something is boggles my mind. My first recommendation would be that you should not know the model. It follows the same reasoning that your first practice paintings should be of strangers. There's less pressure and you don't lose quite so many friends that way.

You'll want to have an easel if you don't mind your paper being upright, or some way to raise the level of the table so you're not bending over your work and ending up with a backache. No, you can't sit, not at first. If you're sitting, you're too cramped and you'll noodle your work. You can sit down for painting details at the end.

Be sure you find an interesting angle to start your art.

The problem an instructor has in helping you is the angles involved. Unless they're seeing exactly what you're looking at from the exact same angle, subtle differences are hard to see.

A classy hat to go with an interesting model. Jason and I traded classroom modeling time for the painting I did of him. We both thought we got the good end of the deal.

We are in a classroom with a dark board behind dark hair and a dark hat. Not wise. A lighter background would have made things easier.

Close one eye and use your pencil to measure details and establish relationships between facial features.

Painting From a Life Drawing

Life drawings and paintings are seldom neat and tidy. Because you're drawing directly on the watercolor paper (the very thing I suggested you not do earlier in the book), your drawing will become a part of the finished work. Don't worry too much about all those pencil lines. Erase any that are not defining the figure, and leave the rest. Use a gentle, kneaded eraser. It's better to leave a few pencil marks than to rip up the surface of your paper with over-erasing.

You'll also need to establish the colors you want to use. Have fresh pigment ready. Because of the upright angle of the paper, I don't wet the surface first but work quickly on dry paper. I use a large round brush and pigment that's not too dark.

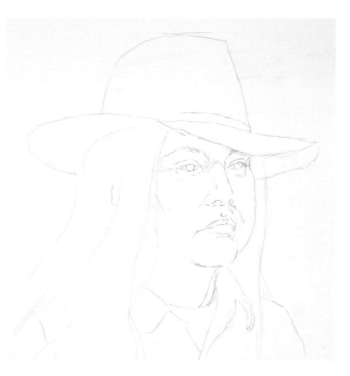

❶ Sketch lightly

Keep your pencil lines light enough to erase, and erase only those lines you will not need.

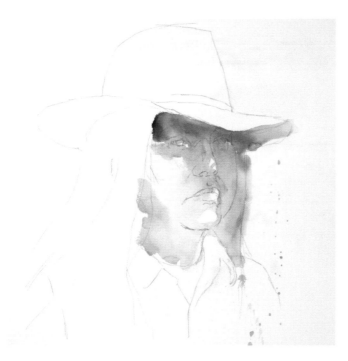

❷ Dive in

Working with dry paper, I establish some of the shapes on Jason's face with Cadmium Red Light and Cerulean Blue. I'm not trying to be neat and tidy, just getting some pigment down on that big piece of white paper.

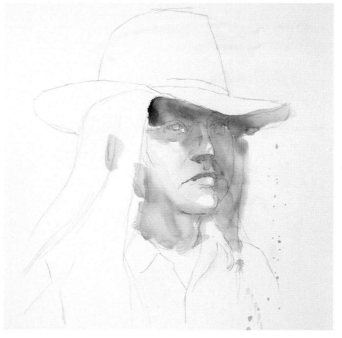

❸ Start to layer

A swish here, a swipe there—I'm breaking up the planes of his face with a layer of pigment under his nose, on his top lip and on the right side of his face. I added Cerulean Blue to his chin area to create the look of a bit of stubble.

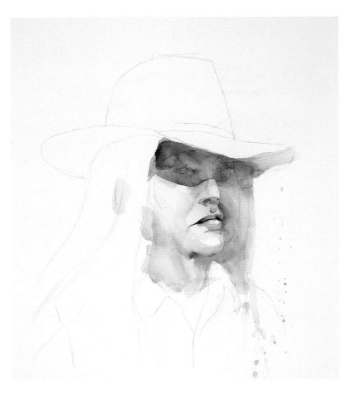

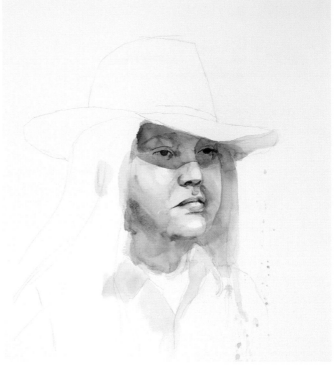

④ Build up the darks

With the addition of the shadowed area (Cadmium Red Light) under the hat, I now have some pretty good darks going on—although the shadow is too red at this point. I applied more pigment to the lips, chin and neck area, and the right side of the face using Cadmium Red Light, Quinacridone Rust and Cerulean Blue.

⑤ Start details

I need to have some details now to see where I should do more work. I painted the eyes, although not the dark they will need to be in the finished work. A bit of Nickel Quinacridone Gold on his cheek changed the tones more. I added a thin wash to separate the hair from the cheek, but I don't worry about the pigment in the hair area as the hair will be developed later and cover it.

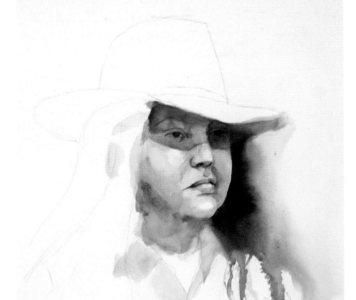

⑥ Need that contrast

I'm at the point now where I need a big hunk of contrasting color hair. As Jason has long, dark hair, I wet down the side of his face, allowing the water to dribble down and off the paper. The pigment will follow the water. I used a mixture of Burnt Umber, Anthraquinone Blue and Cadmium Red. I added Burnt Umber to Cadmium Red and shadowed his left side so his eye was barely visible.

Tip

Challenge yourself in your art. Keep the disasters. It helps you to see your growth.

7 Slow down!

I admit it, I got so involved in the painting that I progressed rapidly through several steps without photographing them. Here's what I did: using the Burnt Umber, Anthraquinone Blue and Cadmium Red, I painted the hair on his right side the same as on his left side, though I did use a wet brush to make it softer on the outside. The hat is Olive Green mixed with a bit of Cadmium Red on the underside. I killed the overly red shadow on his face with some blue and darkened the eye color.

8 Final touches

Sometimes it's hard to stop painting— you just keep hammering away until you simply get tired of it. In this case I still had things I wanted to change, add, subtract, mess with, but I contented myself with toning down the white on the hat brim with a light wash of Cadmium Red, rewetting and repainting the top of the hat, and adding some Cobalt Blue to the shirt.

Composite Painting

One of Rick's best friends, Marcus Smith, wanted to give a special gift to his family. For the first time in over thirty-six years, the whole family was gathering for a reunion. Marcus felt the perfect gift for his myriad cousins would be prints of a painting featuring his dad and his dad's three brothers. In exchange for probably a banjo and some kind of gun (you know how men horse-trade among themselves), Rick was to paint a watercolor placing the four men in front of the family homestead in Cullison, Kansas. The farm had been part of the family for generations. The final painting is a composite of several reference photos shown here.

The original farm in the 1800s. The photo lists John W. Smith, Meda Smith, Arlie Hatfield, Rebecca Ferguson, M. C. Smith and Jesse Smith.

This was the actual photo used for the background farmhouse in the painting.

The four brothers. Details of the faces are almost impossible to see.

This was the reference photo Rick used to create the faces. From left: Anfred, Marvin, Lawrence and Lloyd Smith.

Marcus also provided additional photos to help Rick see individual facial features. It helps that both Rick and I are law enforcement forensic and composite artists.

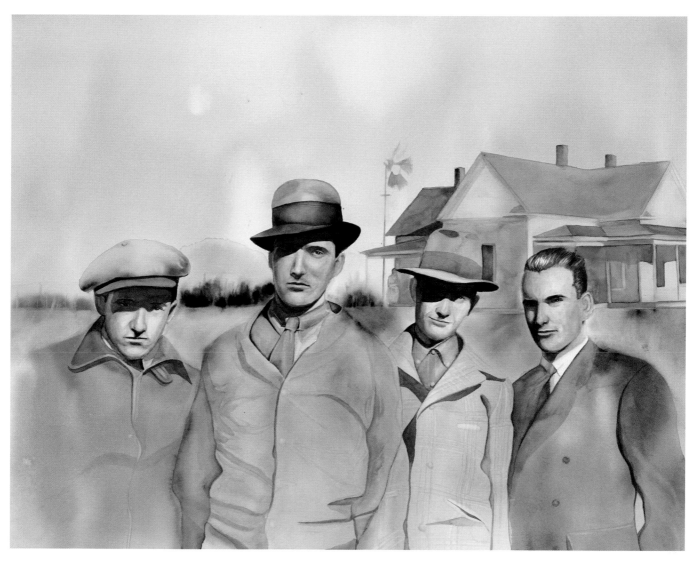

FOUR BROTHERS
22" × 30" (56cm × 76cm)
Transparent watercolor on Arches 140-lb. (300 gsm) cold-pressed paper
Collection of Marcus Smith

Painting on Watercolor Canvas

Ready to stretch yourself? Recently the Fredrix company produced a line of canvas using 100-percent cotton with a special gessoed surface designed for watercolor artists. The advantage of canvas is that you can seal your watercolor with a clear acrylic medium and hang it on a wall without glass.

I was first introduced to this challenging surface when I took a class with artist Tom Lynch. He really liked working on this surface, so I thought I'd give it a shot. Well, I was in for a ride! Fredrix advertises that the surface is easy to clean. That's the understatement of the year. Your paint doesn't sink in, it sits on the surface. One stroke of color is fine. But a second stroke over the first one lifts the first one out. So in order to build darks, you'll need to apply thick paint or dab the pigment onto an area and allow the color to dry. You can also put pigment (M. Graham or Holbein only) into a spray bottle and spray on color (works great for foliage, looks funky on hair).

I uttered many discouraged grumblings as I painted the darks on *The Secret* as each layer lifted the color below.

I gained a bit of smarts on the Payton painting. I didn't get dark. One layer. I'm happy.

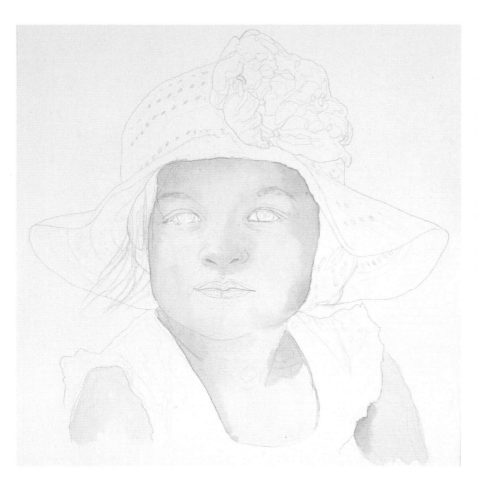

❶ Wash the canvas and begin underpainting

After sketching your piece, take an old rag that doesn't shed (not a paper towel or fabric that leaves little threads, they'll all show up) and wash the surface of your canvas. It will remove some of the HB graphite, which is good as this extra graphite is just waiting to turn your paint gray. Allow to dry. "Underpainting" is somewhat misleading as you can't do much in the way of layering. I'd recommend, if you value your sanity, that you paint a child with few shadows. Here I'm using Quinacridone Rust and Quinacridone Rose.

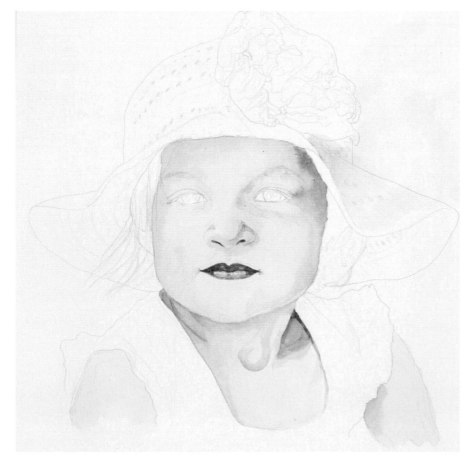

❷ Just paint

To establish darks, you'll need to use rather thick paint and do more of a dabbing technique rather than a stroke. If you don't like it, just stroke again and the color is gone. I used Quinacridone Rust on the face with a mixture of Quinacridone Rust and Quinacridone Rose on the lips.

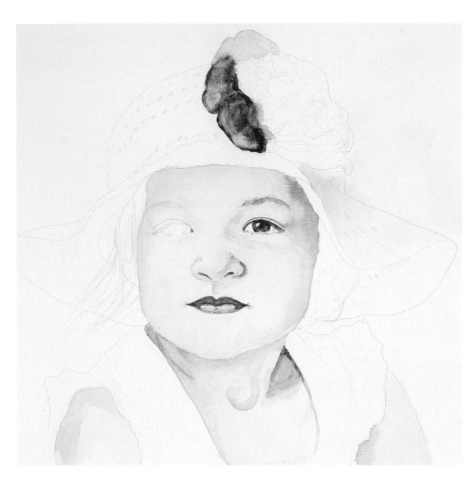

③ Eye and flower

I couldn't do all the great lifts and color variation with her eyes like I can do with watercolor paper, but I can paint a pretty straightforward eye and eyebrow. Her eyes are Burnt Umber and Sepia. I started with the flower on her hat and played around with it using a color shaper. This rubber-tipped tool can be used to push color around on your paper, rather like a squeegee. I used Quinacridone Rose, but I didn't like the results, and I thought the flower's brightness overwhelmed the little girl's face.

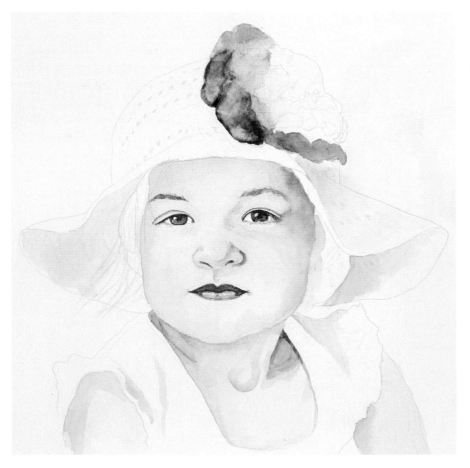

④ Adjust

I finished her right eye, then mixed up some Quinacridone Rose, Quinacridone Violet and Cerulean Blue and used it to shadow the hat. I also added Quinacridone Rose to the face and lips to move the pinker color downward. I washed out the flower and started repainting it.

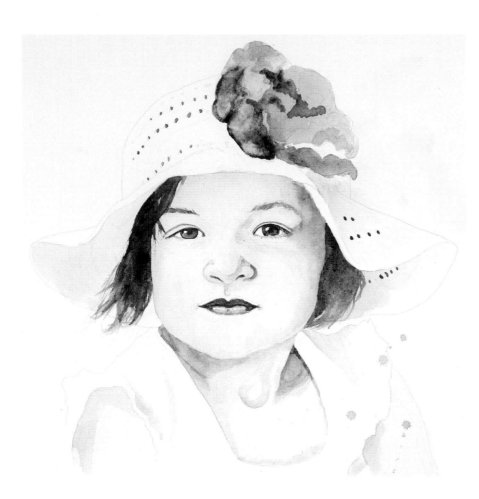

5 Keep going

I've darkened a few shadows on her face with Quinacridone Rose. The hat shadow is a mix of Quinacridone Rose and Cerulean Blue. Her hair is Burnt Umber and Sepia. The canvas is dry for all these areas. You'll notice how very few steps there are in painting a canvas. A simple correction can end up washing out her face. I threw some splashes of paint on the surface. Not so crazy about the result. I'm finding this piece . . . safe. Looks like the girl. I could easily give it to her parents and they'd love it.

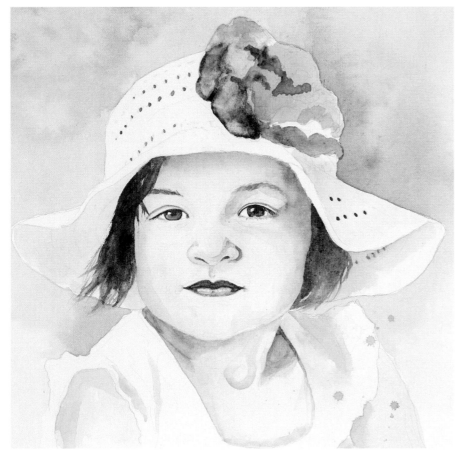

6 Finish

This turned out to be a rather sweet painting. I used Cerulean Blue, Azo Yellow and some Anthraquinone Blue in the background. Notice the crawl-backs and swirls from the pigment just sitting and drying on the surface. You can spray the painting once it's dry with a clear acrylic medium, and it's ready to hang. No glass needed.

Watercolor on Gessoed Board or Canvas

Rick really loves the way many illustrators use the applying and lifting of pigment to form an interesting painting. Of course, they use oils or acrylics. Rick decided to try it with transparent watercolor. Silly man. Furthermore, he wanted to paint his dad for the Dedication page in the back of this book, and give his dad the finished painting. See? Men never listen to us. I thought I'd humor him and photograph his progress.

Okay, sometimes, or maybe this once, I was wrong. It turned out beautifully. If you're up for a challenge, I'll explain how he did it.

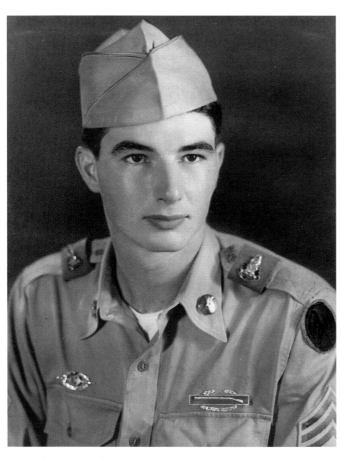

Rick's dad, Don Parks, served in Korea. Rick wanted to paint his dad from this photograph.

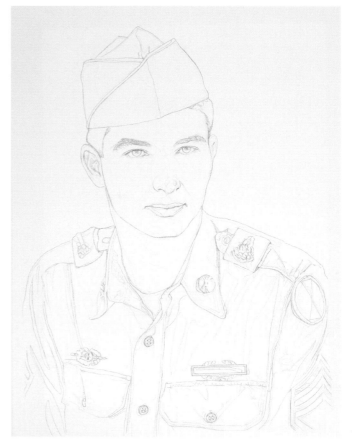

① Drawing and sealing

Rick used a stretched Fredrix canvas. After drawing his dad with a 6B pencil, he sealed the pencil lines with a 50/50 mixture of acrylic modeling paste and acrylic gel medium, diluted with water to the consistency of molasses. He used a cheap, 1-inch (25mm) flat brush and somewhat vertical strokes to apply it.

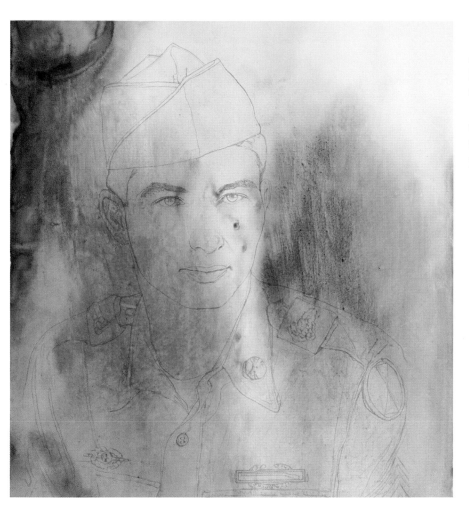

After gently wetting the canvas, Rick brushed Olive Green, Burnt Umber, Quinacridone Rust and Shadow Green (a Holbein color) onto different areas of the canvas. To move the paint, he gently rocked the canvas as he sprayed a fine mist of water. Then he let it dry.

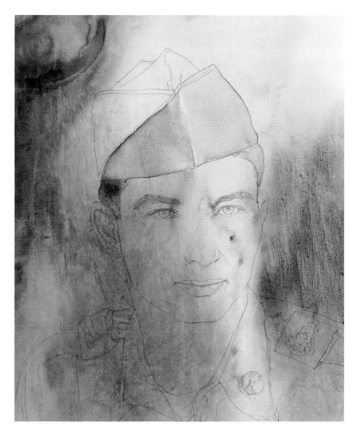

③ **The hat**

The surface of this canvas is very much like the canvas I used in the preceding demo—that is, color will lift completely from it with one stroke. This means Rick won't be painting his dad's khaki uniform. He'll have to imply the color. To do this, he lifted somewhat the color in the hat and carefully painted in Raw Sienna. He also mixed Burnt Umber with Anthraquinone Blue to darken the hair. While the hat was still wet, he lifted a few highlights with a damp, clean brush.

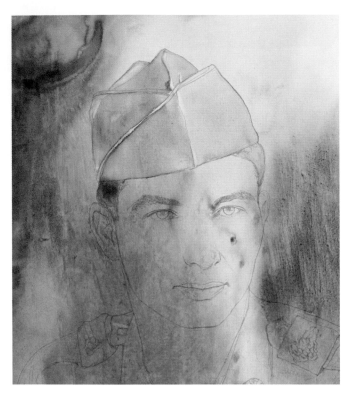

4 Finish the hat

Using slightly more pigment, he finished the hat. He used a small amount of Burnt Umber to place a shadow toward the top.

5 Start the face

Rick wet the right side of the face with clean water. While it was still wet, he removed the pigment, causing that side of the face to be lighter. More strokes, more light. He lifted the whites of the right eye and down the nose. He put a dot of Quinacridone Rust to start a shadow on the tip of the nose, then added Quinacridone Rust above the eye to start a shadow.

6 Lips, eyes and nose

He wet the highlights of the nose carefully, then, while it was still wet, he darkened the side of the nose into the eye with Burnt Umber. He painted the lips with Quinacridone Rust. The darkness between the left eye and the bridge of the nose is a mixture of Quinacridone Rust and Burnt Umber.

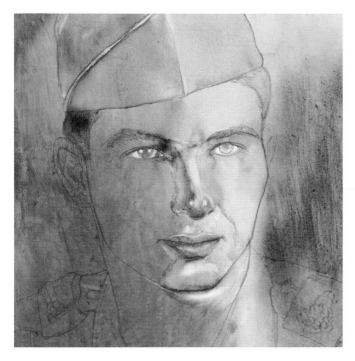

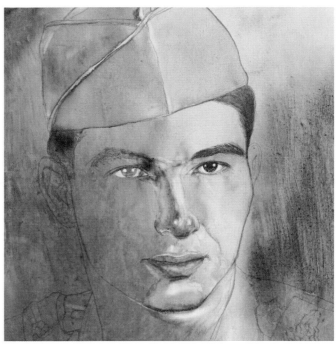

⑦ Chin and neck

Rick wet the chin area just slightly, then added Quinacridone Rust mixed with Olive Green and Anthraquinone Blue to create a shadow. He lifted a lighter area in the chin at the same time. The shadows under the lip are Burnt Umber and Quinacridone Rust.

⑧ Hair, eyebrows and eyes

At this point Rick needed a few good darks. He used very thick paint with very little water. The darks in these areas are all combinations of Quinacridone Rust, Burnt Umber, Anthraquinone Blue and Olive Green.

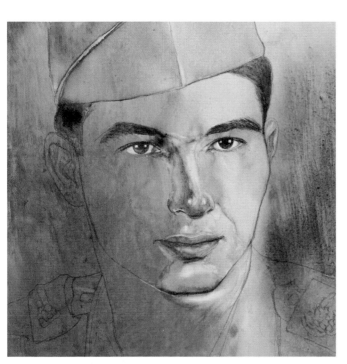

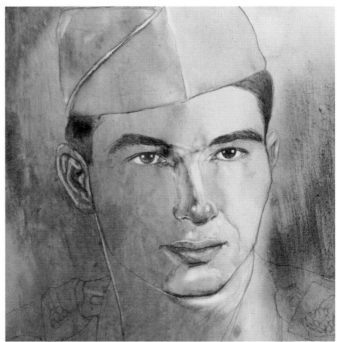

⑨ Right eye, left ear

Rick wanted to create lost and found edges, so both sides of the face weren't treated equally. He painted the left eye using lighter colors (same batch as before, more water). He also lifted color and added color to the right ear.

⑩ Right ear, reflected light

Rick lifted and darkened the left ear, lifting a small area at a time. When lifting color, put the water on first, wait a second, then lift with a stroke or two. The water needs a moment to work on the pigment.

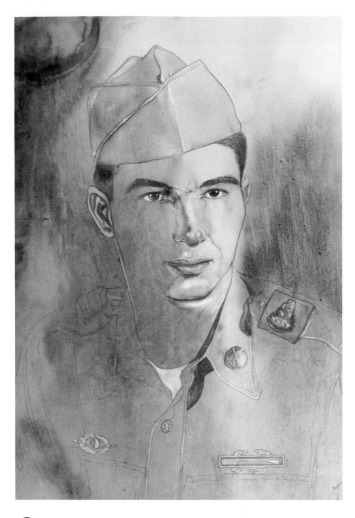

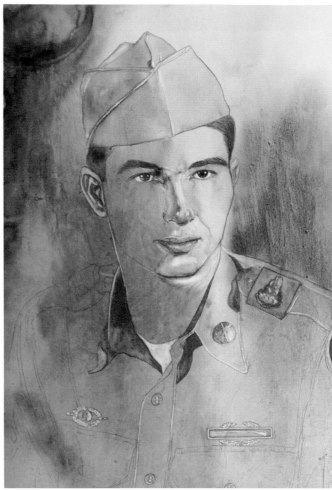

⓫ Adjust values and start clothing

Now that most of the lights and darks were in, Rick could adjust some of the values. He darkened the right eye and eyebrow so they would gradually get lighter toward the outside of the face. He worked more on the left ear, adjusting the midtones. He started working on the clothing by lifting lights in some places. And he added some darks using Burnt Umber mixed with Quinacridone Rust.

In working this way, you'll decide what you want to bring forward and what you want to remain as a subtle pencil drawing. Rick wanted some of his dad's military emblems to show, so he worked on those to create interest.

⓬ Shadows

Don's right side was to be part of the background, and Rick wanted more darks on that side. He darkened the collar, then lifted color off the left shoulder to separate it from the background.

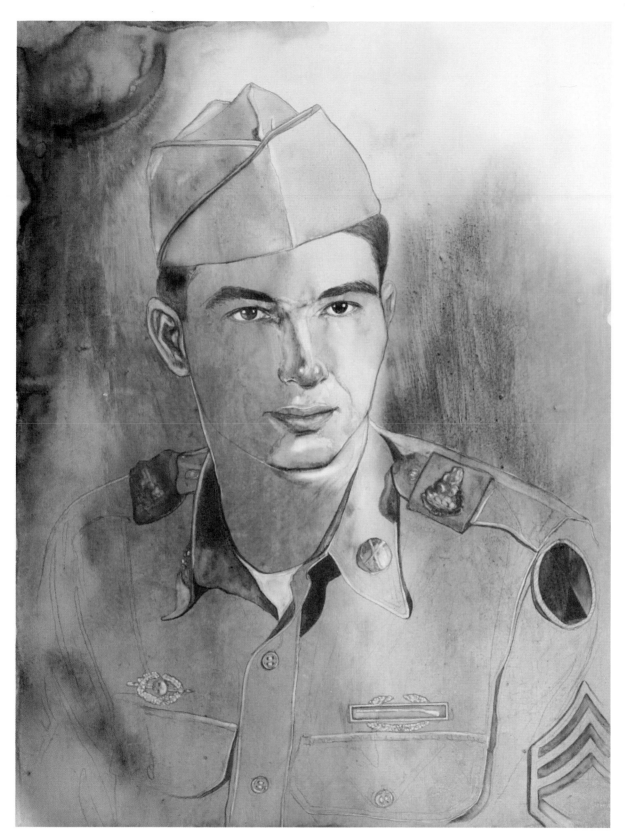

⑬ Final details

A smidge more detail in the patches and medals, adding some interesting darks and lights on the clothing, and Rick's almost done. The point now is to keep the viewer's gaze within the painting. The darks shouldn't run off the paper or canvas. Any final details should add to the art. Don't noodle it.

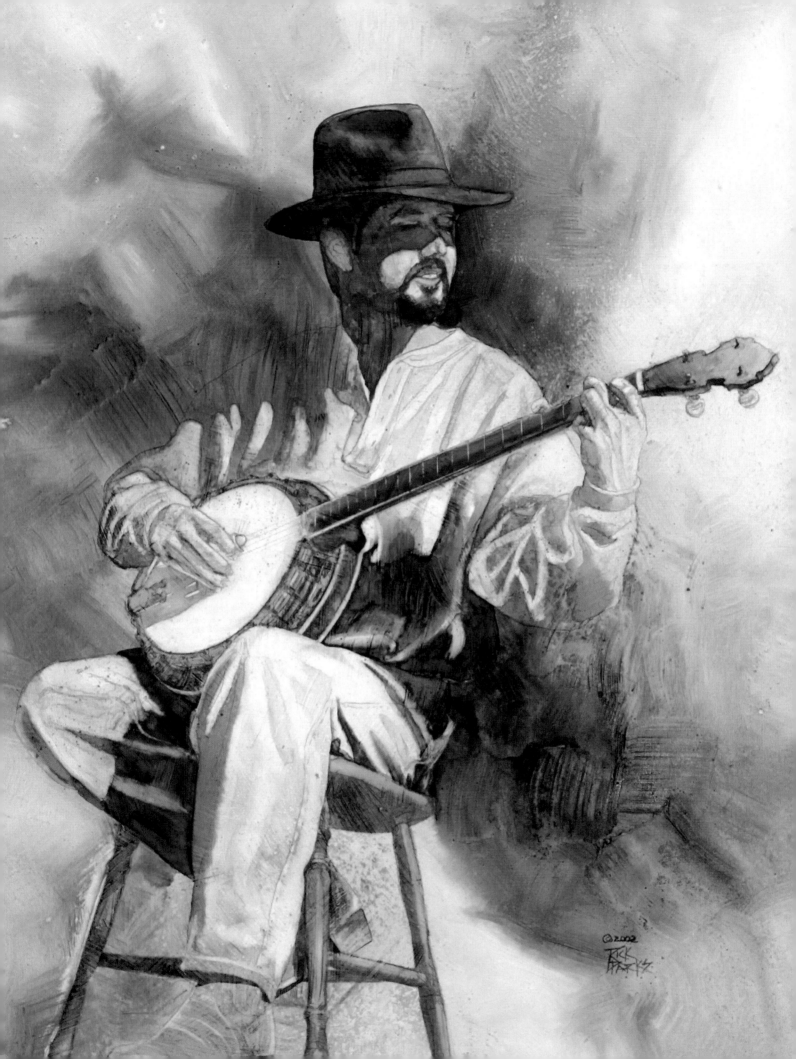

Conclusion

*A craftsman knows in advance what the
finished result will be,
while the artist knows only what it will be
when he has finished it.*
—W. H. Auden

Watercolor isn't like any other medium. It has a mind of its own, much like
my bull terrier. Or my husband, come to think of it. You're simply not going to
make it mind or control it in any reasonable way. I remember what one of my
first watercolor instructors, a wonderful woman who taught at Spokane Falls
Community College, once said, "You have beautiful paints and paper. Let them
do the work for you." I still hold to that today. If the painting isn't exactly what
I wanted to have happen, it just might still be an interesting painting when I'm
finished.

The paintings presented herein are shown step by step exactly as I painted
them, burps and all. An honest book will show you how to get into and out of
problems and encourage you to keep painting. That's the real secret: keep paint-
ing. Visit me sometime, join one of my classes. You can watch me up close and
personal making a royal botch-up of a painting and fixing it . . . or not. After all,
it's only a piece of paper.

Tip

*Don't forget to drop me a line at carrie@stuartparks.com.
I love hearing from you.*

RICK, SELF-PORTRAIT
30" × 22" (76cm × 56cm)
Transparent watercolor on gessoed board

Other fine North LIght Books are available from your
favorite bookstore, art supply store or online supplier.
Visit our website at www.fwmedia.com.

media

16 15 14 13 12 5 4 3 2 1

Distributed in Canada by Fraser Direct
100 Armstrong Avenue
Georgetown, ON, Canada L7G 5S4
Tel: (905) 877-4411

Distributed in the U.K. and Europe by
F&W Media international, Ltd
Brunel House, Forde Close, Newton Abbot, TQ12 4PU, UK
Tel: (+44) 1626 323200, Fax: (+44) 1626 323319
Email: enquiries@fwmedia.com

Distributed in Australia by Capricorn Link
P.O. Box 704, S. Windsor NSW, 2756 Australia
Tel: (02) 4577-3555

Edited by Kathy Kipp
Design and layout by Laura Spencer
Production coordinated by Mark Griffin

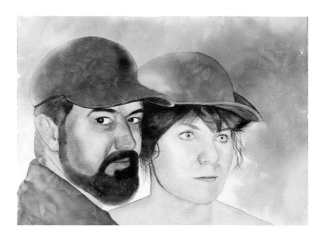

ABOUT THE AUTHORS

Best-selling authors Carrie Stuart Parks and husband Rick Parks
are forensic artists who teach classes throughout the nation. Their
forensic art has appeared on multiple television shows, includ-
ing *America's Most Wanted* and *20/20*. In addition to teaching,
they both create fine art in pencil, watercolor, pastel pencils and
stone carvings. Rick works with some of America's finest luthiers,
designing, carving and applying his unique art images on musical
instruments that have been featured in custom guitar books. Car-
rie is a signature member of the Idaho Watercolor Society and has
won numerous awards for her paintings. Rick and Carrie are the
authors of several successful North Light books, including *Secrets
to Drawing Realistic Faces* (2002), *Secrets to Realistic Drawing*
(2006), *Secrets to Drawing Realistic Children* (2008) and *The Big
Book of Realistic Drawing Secrets* (2009). Visit their website at
stuartparks.com.

Metric Conversion Chart

to convert	to	multiply by
inches	centimeters	2.54
centimeters	inches	0.4
feet	centimeters	30.5
centimeters	feet	0.03
yards	meters	0.9
meters	yards	1.1

Dedication

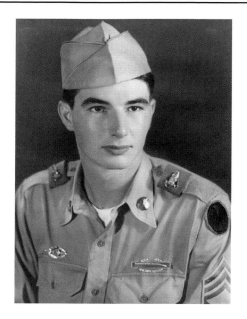

After deciding to dedicate this book to my dad, I reflected back on not only his life, but also the lives of his family before him. Richard Parks arrived at the newly established Massachusetts Bay Colony in 1635. Dad's other indigenous ancestors were there to greet the newcomers. As the year 1776 approached, John Adams declared "My generation of Americans have to be soldiers so our sons can be farmers and merchants so that their sons can be artists." My dad's ancestors, David Parks and his son Leonard, a fourteen-year-old fifer who was at Lexington when the first shots were fired, would be among the soldiers Adams spoke about. Ironically, my dad had to be a soldier, then a merchant and finally a farmer before I could become an artist. Adams's prophetic words came true in my family exactly two hundred years and eight generations later.

Dad spent two decades in management before his company shut down operations in Virginia. With the steely resolve that is only possible if you were raised during the Great Depression, he embarked on a new career that would define his life and become a great inspiration to me. He started by buying antique furniture, which he would repair and refinish to sell. He later purchased a furniture refinishing business that he tripled in size while he started building his own authentic primitive furniture. I was not surprised when I discovered that Dad's grandfather, Bond, and his sons were all highly skilled cabinet-makers. During this period Dad purchased a farm on the beautiful Shenandoah River in Virginia's Blue Ridge Mountains. The original portion of the farmhouse was built in 1801. For the next thirteen years, Dad would repair and refinish the biggest antique restoration project of his life, and it would become his cherished home.

I have been inspired my entire life seeing how this wonderful man overcame so many obstacles through determination and hard work. He restored the beauty of antique pieces of furniture and created originals with his own hands, instilling in me a great love of history and craftsmanship.

I dedicate this book to my father, Don Parks, with the hope that one day, one generation will not have to be soldiers just so future generations can have the privilege of being artists.
—Rick Parks

Acknowledgments

Rick and I would like to thank every human being who has helped us in our lives, but I guess that would take too long. The short list would start with the fine folks at North Light Books who gave us the chance to do this book. We'd like to especially thank Mona Michael, Jennifer Lepore and Pam Wissman. Our wonderful editor, Kathy Kipp, deserves an especially big thank you. She's the perfect editor: brilliant and with a sense of humor. What more could we ask for?

Our artistic friends contributed so much to the content, with a big hug once again to the Art Camp ladies. We owe a huge debt of gratitude to our forensic students for joining us in class for so many years and helping us grow as artists and instructors. The photographs that make our art so easy came from several gifted photographers: Andrea and Dave Kramer of Stampede Lake Studio, Idaho (stampedelakestudio.com); Joe Lofy of JKL Images, New Berlin, Wisconsin (jklimages.zenfolio.com); and Ernie Fischhofer of Medicine Hat, Alberta, Canada. To the numerous models who posed for the art: many, many thanks.

We hope you will join us for an artistic venture in the future. Please check our schedule on stuartparks.com or drop me an e-mail at carrie@stuartparks.com.

I wouldn't be able to write much more than an e-mail without my writing mentor, Frank Peretti. Finally, Rick and I would like to thank our Lord and Savior Jesus Christ in whom all things are possible.
—Carrie Stuart Parks

Index

Ideas. Instruction. Inspiration.

Receive FREE downloadable bonus materials when you sign up for our free newsletter at artistsnetwork.com/Newsletter_Thanks.

These and other fine North Light products are available at your favorite art & craft retailer, bookstore or online supplier. Visit our websites at **artistsnetwork.com** and **artistsnetwork.tv**.

Get your art in print!

Go to splashwatercolor.com for up-to-date information on all North Light competitions. Email us at bestofnorthlight@fwmedia.com to be put on our mailing list!